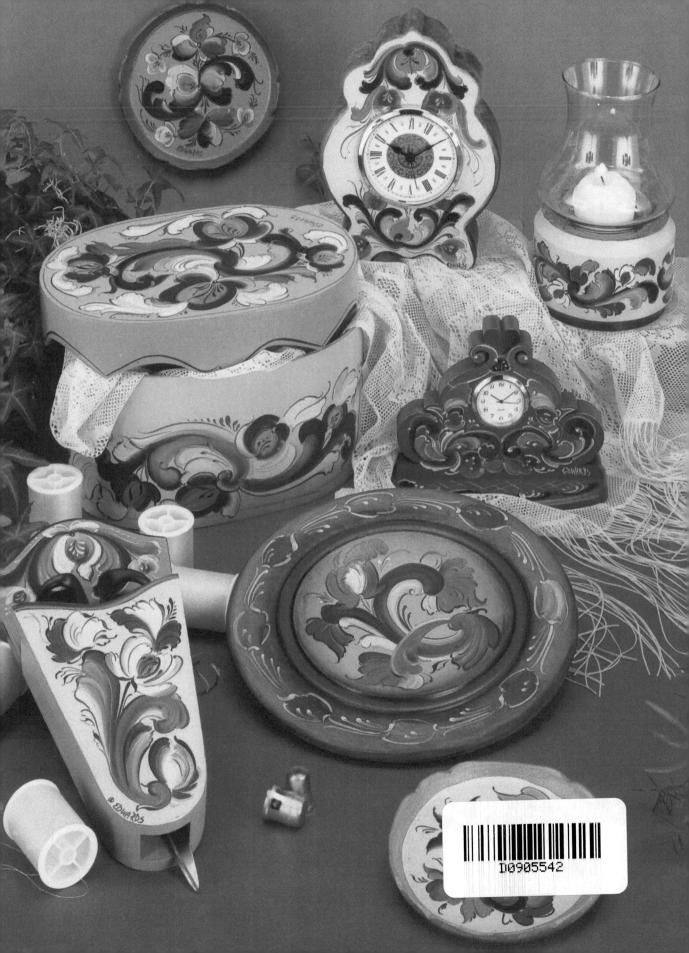

DESIGN BASICS FOR TELEMARK ROSEMALING

ALL NEW ORIGINAL PROJECTS

Rosemaling is the Norwegian decorative art which began about 1700 and declined in the late 1800's. This beautiful floral art form was developed by folk artists and has had a resurgence of interest in both America and Norway. This book discusses the Telemark style which is one of many types developed in the different districts of Norway. Characteristics of the Telemark style are that it is painted freehand and asymmetrically with fresh transparent colors. Telemark can be used on any piece when the general rules of design and characteristics of Telemark rosemaling are understood. This book can help you learn the basic skills and proper design forms to paint your own traditional, creative designs.

A sequence of lessons is given for teachers. I also have a curriculum available. Please contact me for this.

A pattern packet of the designs from the first edition of this book is available with colored photos from the book from the author for $9.95 plus $2.50 S&H. A curriculum is available for $7.50 plus $2.50 S&H. MC/V/or DISCOVER 719-589-3308.

THANKS to Carol Steers and Pam Hostetler who read and corrected this manuscript. A big thanks to all my friends and students who encouraged me to write and publish this book through some daunting odds and despite those who said rosemalers will never read it!! Rosemalers are such special people!

This book has been revised from its 1994 edition. Although no information has been deleted, it has been rewritten to give clarity to some areas and to better explain others. I have also added more information and more examples of strokework. A full-time Rosemaler since 1975, I have a BS and a MA in Art/Education and have a business, Rosemaling and Crafts. My rosemaling studies have been extensive, having studied with many Norwegian and American teachers.

TABLE OF CONTENTS

Dedication: To my husband Dale, children Liesl and Brion and my parents who always believed in my obsession with all things Norwegian. To all my Rosemaling teachers and the Museum who gave us all the chance to learn the right way.

PAINTING GOALS FOR ROSEMALERS

1. Create well-shaped scrolls.
2. Understand root position.
3. Balance the composition.
4. Understand color tonality (one color is queen).
5. Place flowers correctly.
6. Correct placement of linework.
7. Create expressive detail.
8. Designing to fit the piece.
9. Lazuring.
10. Accomplish a lasting and professional finish.

This book is published by:
Diane Edwards c2011
Nordic Arts
3208 Snowbrush Place
Fort Collins, CO 80521
Home: 970-229-9846
Fax: 970-229-5683
www.Nordic-Arts.com
Blog:
http://DianeEdwardsArtDoodles.blogspot.com
www.DianeEdwardsArts.com
Diaedwards@cs.com **for orders.**
MC/Visa

Folk Art Books by Diane Edwards
Books available:
- Design Basics for Telemark Rosemaling Vol. 1 and Vol. 2
- Rosemaling Boxes
- Norwegian Rosemaling for Young People
- Design Basics for Swedish Folk Art
- Swedish Folk Art: Floral and Kurbits Designs
- Sigmund Aarseth's Rosemaling Design
- Aarseth's Painted Rooms

INTRODUCTION

In 1970 my cousin Lynn Peterson and I traveled to Norway to discover our "roots". We were thrilled to meet our Peterson relatives and explore the old town of Vik i Sogn from which our paternal grandfather had immigrated. From my first view of Norway, even from the plane, I was "hooked" on all things Norwegian. We had been born and raised in a new land, with little previous history that we knew of—now suddenly we were surrounded by thousands of years of history. Churches that were built in 800 a.d. were almost beyond our comprehension. Painted interiors created by someone in the year 1600 were mind boggling. One could study old work, see it, touch it and breathe in the air of the old wooden houses, cabins and stabburs. Norwegian wood has its own peculiar bouquet—a mixture of pitch, pine, and hundreds of years of history.

My earliest memories of my grandfather, Halvor Peterson, were of sitting in his shop watching him work with wood and the smell of sawdust and paint as he created beautiful wooden pieces. It's not too surprising, then, that I went on to major in art and teach it for many years. It wasn't until 1974, however, that I began to think of rosemaling as something I could do myself.

My actual participation in rosemaling classes came after two years of hard work painting all the small selection of patterns that were available at the time and an almost complete memorization of Sigmund Aarseth and Margaret Miller's book, "Norwegian Rosemaling".

My first classes were with Jackie Klokseth, a wonderful friend and teacher who had one of the first Rosemaling shops in Fargo, North Dakota. Jackie was constantly encouraging and was also totally fascinated herself with Norwegian art. Her untimely death in 1980 was a profound loss to rosemaling, her friends and family. One of her greatest assets as a teacher was to keep us on track of what was traditional and what was just another fad.

Particularly beneficial to the development of my work creatively has been my study with Sigmund Aarseth. One of the premier Norwegian rosemalers,

his work has always been significantly on the edge of change. Because Sigmund is also an Impressionist landscape painter and a decorator of interiors he has a great sense of the use of rosemaling as a decorative art in the context of Norwegian life. Because of his love of the old and interest in the new, he has been an inspiration to hundreds of American rosemalers.

American rosemalers are also greatly indebted to Dr. Marion Nelson and the Norwegian-American Museum Vesterheim, in Decorah, Iowa. Dr. Nelson brought over Norwegian rosemalers for us to study with and has encouraged Americans to keep within the tradition. Vesterheim sponsors the National Rosemaling Exhibition and the Rosemalers Newsletter. The collection of the Museum and the Library are open to rosemalers for study. While the Museum has promoted traditional rosemaling, they have also encouraged the natural evolvement of a developing art form in American rosemaling. They recognize that no truly authentic art form can become stagnant and static and keep its vitality. Although there are fads and fashion trends and adaptations, the great strength of rosemaling is in its roots, which are based on design principles of all time. It is for this reason I am writing this book—to hopefully explain and illustrate the roots of Telemark rosemaling, its basis on ornamental stylistic forms of European art, and its development in Norway during the 18th and 19th centuries.

I'm not sure what particular chord the Telemark style struck in my creative brain, but from the first moment I saw the graceful curve of the scrolls, the movement and rhythm of the designs and the fluid dance of the lines, I was totally enamored. To this day, nothing satisfies my eyes like the beauty of the well-executed Telemark design. Since my beginnings in rosemaling, I have struggled through countless weeks of study in all the various styles, but have always come back to Telemark. It fits my nature, and seems a part of who I am. I hope I can describe it to you so that you can feel its rhythm and hear its music play for you.

SUPPLIES

OIL PAINTS - Chroma Archival Oils
1) TW-Titanium White
2) YO-Yellow Ochre
3) PB-Prussian Blue
4) ERL-English Red Light -
 (VR - Venetian Red is now substituted for ERL, a
 discontinued color)
5) BU-Burnt Umber
6) BS-Burnt Sienna
(Beginners need first 6 only.)

7) RS-Raw Sienna
8) B-Ivory Black
9) AC-Alizarin Crimson
10) GU-Greenish Umber
11) CRL-Cadmium Red Light
GU is a Rembrandt brand paint

Mediums
Pale Drying Oil or Linseed Oil
Odorless Mineral Spirits
(Use baby oil to clean brushes
as you paint, use MS last)
Lard Oil or brush conditioner

ACRYLICS
1) TW-Titanium White-Jo Sonja (JS)
 or DecoArt Americana (DA)
2) YO-Yellow Oxide-JS
 Antique Gold-DA
3) PB-Prussian Blue—JS or DA
4) CRL-Cadmium Scarlet-JS
 Cadmium Red—DA
5) BU-Burnt Umber—JS, Dark Chocolate—DA
6) BS-Burnt Sienna—JS & DA
(Beginners need first 6 only)

7) RS-Raw Sienna—JS & DA
8) B-Carbon Black—JS, Ebony
 Lamp Black—DA
9) BG-Teal Green—JS
 Blue Green—DA
10) DG-Pine Green-JS
 Hauser Dark Green—DA
11) AC- Burgundy—JS
 Deep Burgundy—DA
12) BE-Brown Earth—JS
 Dark Chocolate—DA
13) RU-Raw Umber—JS
 Raw Umber—DA

Mediums:
JoSonja—Retarder, Flow Medium,
All Purpose Sealer, Tannin Sealer, Clear Glaze,
Colored Glazes in Blue, Red and Yellow Oxide,
Kleister Medium for textural effects
DecoArt—Brush 'n Blend, Clear Glaze and Sealer,
Control Medium

OTHER SUPPLIES
Strip palette
Palette knife (Langnickel P1)
Chalk or Stabilo Pencil for designing and borders,
Containers for mediums and water, Sponge brushes
for background painting, Paper towels
Covered, empty coffee can with 1" of water in it for
oily towels, rags,etc.

BRUSHES
Loew Cornell synthetic La Corneille
Series 7500 filberts, Size 2, 4, 6 and 8
Short Liners, Series 7350 or
 Jackie Shaw liner Size 0, 1, 2
Long liners, Series 7050, Size 0, 1, 2

VARNISHES
Oil Base
Minwax Antique Varnish, Satin works well.
Since the flatteners in the varnish sink to the
bottom you can use that to your advantage.
I pour out the top half of the can into a
separate container. Then mix the bottom
half thoroughly. Use the top half for the
first coat (it will be shiny).
Use the bottom half for the second coat,
usually nice and satiny.

Use a good varnish brush, about 1". Use the
3M finishing pads in white or green after the
first coat, NOT steel wool which leaves little
pieces behind.
Water Base
JoSonja Polyurethane Satin or Matte
Follow directions on bottle!

This list is of close equivalents, not exact matches.

BASIC ROSEMALING STROKES

The basic strokes for Telemark rosemaling are the C and S strokes, using the filbert or a flat brush. These strokes are easily accomplished with the filbert because it has a rounded edge that makes an automatic scroll end. (Instructions in parenthesis are for acrylics.)

First clean the brush in turp (or water) and wipe it dry. Touch the brush in oil (or water), load with juicy paint—stroke brush first on one side and then on the other to flatten the brush. This gives you a sharp chisel edge. Be careful not to remove your paint.

When painting a rosemaling stroke prop up your painting arm with your other arm. This is the traditional rosemalers' painting position. By putting wrist over wrist and touching down the center fingers of your left (or opposite) hand you will be able to support a strong, deliberate stroke which is well-controlled. Your goal is to complete all your strokes from top to bottom with firm control and no shaking as you near the end. This takes a little practice.

Rosemalers need hand support—but don't get a wooden bridge or use your little finger, these supports create a dependency that cause problems when you paint a three-dimensional object or something large. Your other arm is always with you and is quite adaptable to odd shapes. You'll never regret learning how to do this.

The "C" stroke: Hold the brush upright as you press down firmly at the beginning of the stroke. Press the brush down all the way at the beginning of the stroke and then start to lift while pulling through the stroke. At the end of the stroke the bristles return to a chisel edge.

The "S" stroke: Hold the brush vertical on its chisel edge. Angle the brush on a diagonal line and slowly press down until the brush is fully extended and then start gradually easing up as you pull the brush back on to its chisel edge.

WHEN DOUBLELOADING, you will load the brush on one side as described. Stroke it on the palette to remove any extra paint on the edge of the brush. Then, reload the paint side of the brush in a contrasting color. Stroke once on the palette to blend so that you have a blended edge, not a hard line of color. If the edge with the second color on seems dry you might add a little oil (or water) to that color.

LINER STROKES

The liner brush is cleaned first in turp (or water). Then dip into the medium you are using, (oil or flow medium mix). Mix a small pile of paint and oil (or water) with the palette knife to make a paint consistency like melted butter. Load the brush fully, stroking through the paint pulling the brush towards you—never stroke away from yourself with the liner. Twist the point of the brush on the dry palette paper pulling the brush towards yourself. This creates a fine point on the brush. The brush will have a rounded area of paint all the way up to the ferrule. You can then do lines or teardrops with the same brush.

The "secret" to making fine lines:
1) load the brush fully,
2) use your other hand to support your painting hand,
3) hold your brush about an inch above the ferrule, and
4) hold your brush straight up and down and work just with the tip.

If you have bifocals you may have to work at this to get the feeling of just where that brush tip is when you put it down. Linework is done in what I call an "anticipation mode"—you start your liner moving in the direction of the line BEFORE you actually touch down and then follow through slightly AFTER you actually lift it up. This gives a rhythmic movement to your work and since all lines must flow from the root it keeps your design moving correctly.

TEARDROPS are done by loading the liner brush and positioning your arms the same way as for lines. However, when you make a teardrop your brush assumes a 45 degree angle. As you lay down each teardrop you hold your brush down for just a split second and push it slightly out depending on which way you are angling your teardrop. IF your brush is not fully loaded your teardrops will end in a point. Look at the examples of teardrops. Notice how they all follow a line from the stem line or from the root. No teardrops or linework exist independently of the flow of the main design. All linework follows through on the design flow lines of the rest of the design elements.

ROSEMALING IS RHYTHM!!

"C" Stroke. Press,

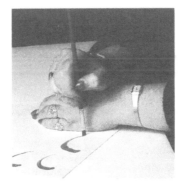
pull and lift to chisel edge.

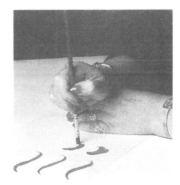
Flower Stroke. Press edge out.

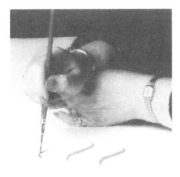
"S" Stroke. Start on chisel edge,

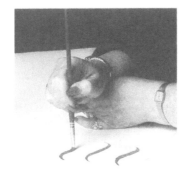
press down fully,

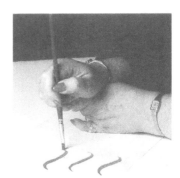
lift onto chisel edge.

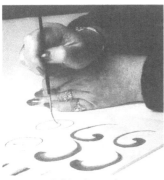
Pull brush around.

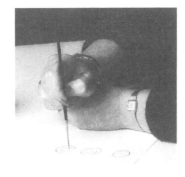
Brush is straight up and down at the end of the line.

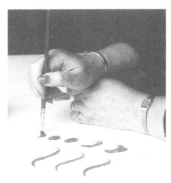
Center Oval Stroke. Chisel edge, press down fully, pull back up to chisel edge.

Tear drops - 45 degree angle. Start with point, press down and push brush out.

Press down as for tear drop,

Push out and lift out tail with point of brush.

Leaf.

LESSON ONE - SCROLLS

In Telemark rosemaling the scrolls are the primary design element, therefore, it is vital that you get the shape and the feeling of the OVAL into your design-center consciousness. Look at the shape of the scrolls, and try to visualize an oval superimposed. It is very important that the scroll always be ROUNDED. No flat places should be seen. The sweep of the brush goes through the heavy pressure at the beginning of the stroke and then lifts slightly going onto the chisel edge of the brush. The second stroke starts slightly IN FRONT OF the first stroke creating more of a ball at the beginning of the scroll. This stroke also goes all the way to the root of the design but it stays INSIDE the previous stroke. Do not overlap this stroke or cross over the previous stroke. It will be ON the first stroke but remain inside its inside edge. See the illustration.

You should do these strokes until you have a well-shaped scroll. A waxy palette really works well and gives your brush lots of skid for practicing long strokes.

Next, each scroll can have several supporting scrolls under it, these can be C scrolls or S scrolls. (They can be the same color or other colors. There are few rules for color placement in Telemark—you mainly work for color balance.) Scrolls can be added anywhere there is a root. The main root is usually at the bottom of the first big C scroll—further roots are at the ends of any scrolls. You can paint C scrolls into or out of these roots. After the C scrolls you can add S scrolls beside them. Remember, S scrolls rarely stand alone, they get weak and spindly.

Scrolls can also grow from or through a flower. (The scroll is not painted inside the flower) Again, use a C scroll or a C and then an S scroll. These scrolls should not be bigger or longer than the main design scrolls. Scrolls should decline in size as you paint out into the design. A large scroll which doesn't connect visually to the main design center can really misshape the whole design flow. (A possible exception to this would be when you are working with a long, horizontal design; the scrolls can be similar in size as you go along to keep the movement even. See illustration Scrolls page 11.)

SCROLL CRITIQUE

Some things to look for in your scroll designing:
1) Always start with a C scroll—it can face either way.
2) Use two strokes for each scroll—ARE THEY ROUNDED?
3) Use enough supporting scrolls to strengthen the C scroll.
4) Establish where your primary root will be (probably at the bottom of the main C scroll); it doesn't have to be painted in—just know where it is.
5) Add C and S scrolls coming into the main root area—any color—work for color balance.
6) Plan for flower placement, you can place the stems.
7) Add C or S scrolls into the top ends of scrolls—at the secondary roots.
8) Check the V or Y area between scrolls—is it a smooth, even separation?
9) Paint or indicate flowers with circles.
10) Add scrolls from flowers if desired.

EXTRA PATTERN

8

LESSON TWO - FLOWERS

Telemark flowers are pure fantasy or imaginary forms. They are built up with a series of C and S strokes. The stems that create the flowers come from:
1) the main root of the scroll,
2) the splits in the scrolls or
3) from the secondary roots or the ends of the scrolls.

Secondary flowers, which are always smaller, come from the larger flowers. The stem lines of these flowers can come from any part of the **first** flower—BUT must follow through from the original stem line. It is though an imaginary dotted line would come right through the flower and to the next flower. Although actual connections will usually not occur, one should be able to visualize the flow of the line.

Telemark flowers are created in four general shapes. The first is a large flower surrounding or even covering the primary root. This flower doesn't need a stem, and should be large enough to fit the space centering the root. A little flower here would look out of place. Smaller flowers, not too many, can grow out of this root flower. *(see page 35)*

The **second** flower shape is based on a dot. It is a small flower and the stem comes up to the dot and then the flower is painted.

The **third** flower shape is based on a crescent or eye-brow shape. The stem comes up to the crescent and the C and S strokes form out of that.

The **fourth** shape is based on a circle. The stem doesn't touch the circle but stops next to the petals. The circle is surrounded by petals of a C and S shape.

Flower placement can really enhance a design but should not draw the eye away from the scrolls.

Scrolls can come from crescent or circle flowers—the dot flowers would be too small to sustain the weight of the scroll. Scrolls could also come from the central root flower but would take major design skill not to make it look too off-balance. In many cases, a scroll outline with a liner brush would be better than a solid shape.

The most interesting flowers are not heavily painted. They are transparently stroked in and then can be edged with side loading with the filbert brush.

The **brightest color** should be used in the primary root area with touches of this color in the outside design. They can then be outlined with interesting variations of liner work. Thin and thick strokes, and different outlining color variations can be used.

Telemark flowers are only as limited as your imagination! Look at some of the photos of old rosemaling for ideas, you will be astounded at the versatility of the Old Masters.

EXTRA PATTERN

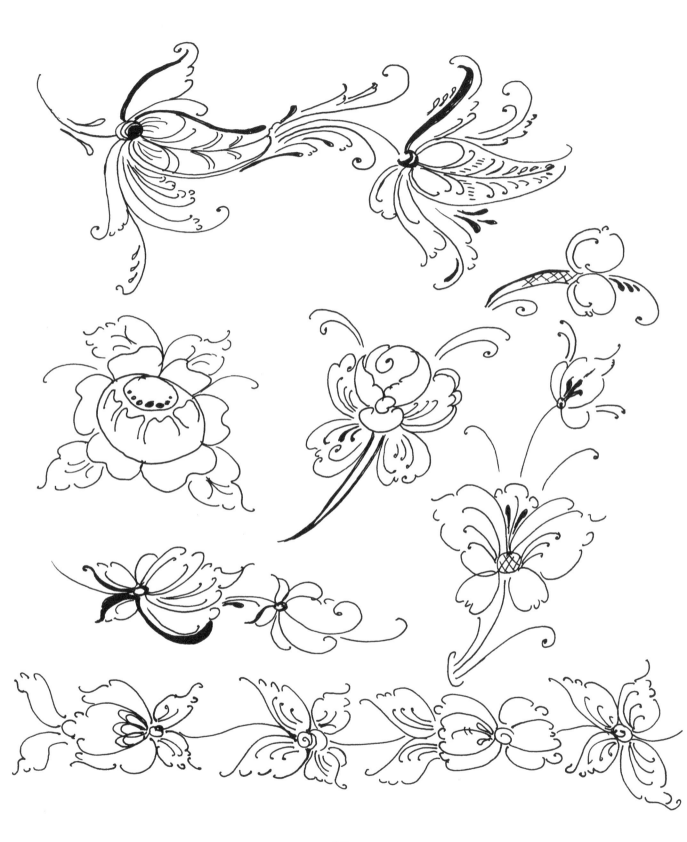

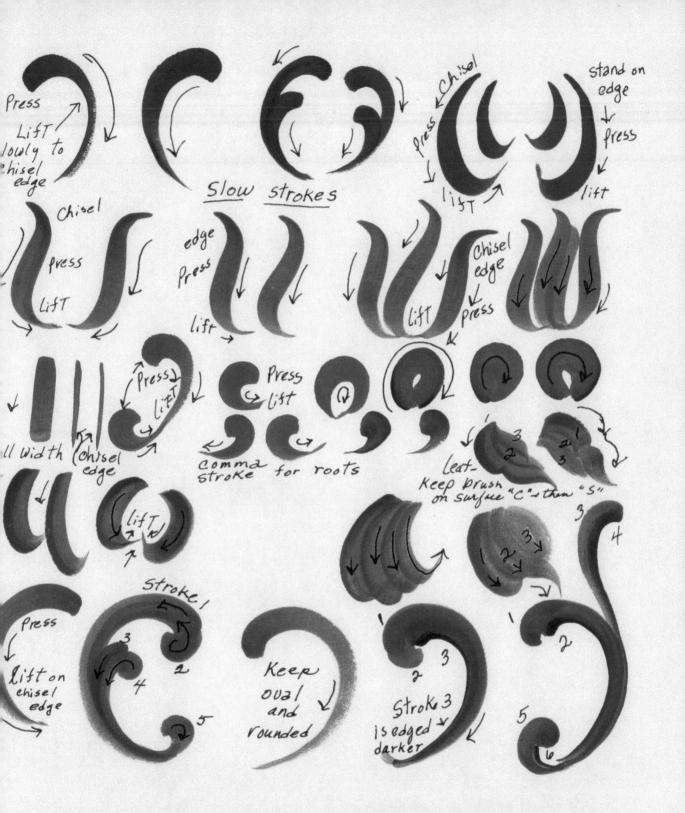

Basic Strokes - Use a size 4 brush - place palette paper over stroke sheets to practice. You may copy sheets. Count to 4 when doing strokes. Give bristles time to resume their shapes.

11

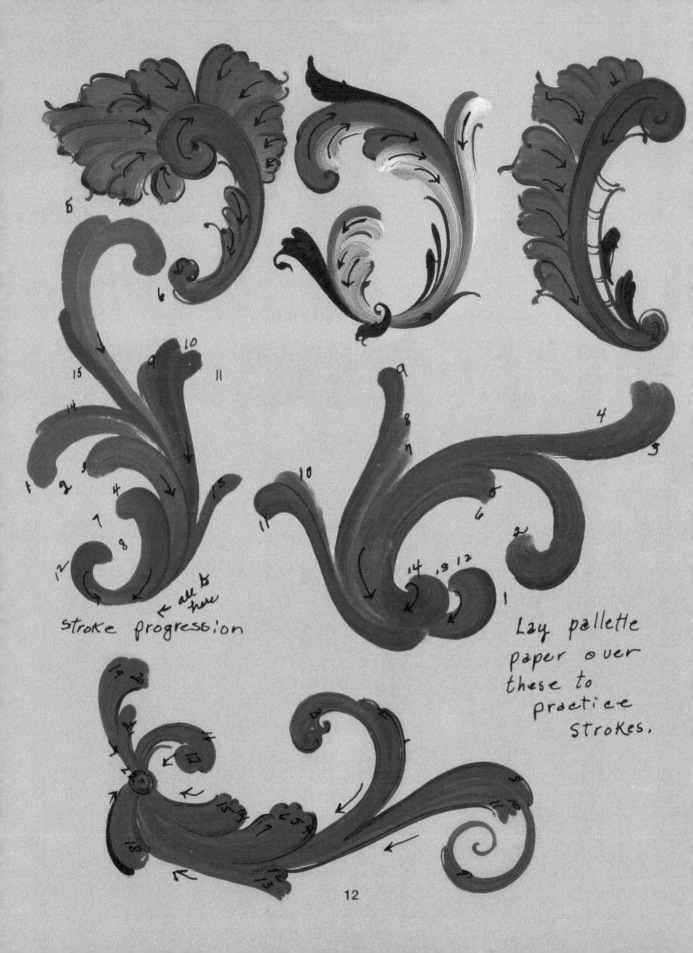

stroke progression

Lay pallette
paper over
these to
practice
strokes.

12

LESSON THREE - COLOR

This chapter will discuss traditional color. In the history section, I mention that the decline of rosemaling came about because of the great variety of easily available colors in tubes. Well, there are even more colors today. There are dozens of brands, dozens of shades and tints of every possible color known to man. Hopefully, this chapter will give you something of a road map to find your way through the maze!

It is important that you know that color in Norwegian rosemaling is TONED. This means that an earth color is added to each color in varying amounts. The earth colors, which can often be used straight out of the tube are: Yellow Ochre (Yellow Oxide, acrylics in parenthesis), Raw Sienna, Burnt Sienna, Burnt Umber, Raw Umber, Red Ochre (Red Earth), Greenish Umber (no exact equivalent in acrylic) and Ivory Black. These colors are used as toners along with Titanium White. Because earth colors are fairly transparent straight from the tube, sometimes they need a little bit of white added to show up on some backgrounds.

My palette set-up is extremely simple; in my study of early Telemark, I haven't seen any mixtures that lead me to believe that the Old Master's spent any more time mixing their colors than I do. Telemark color must be clean and transparent so don't let your colors get muddy.

The basic color scheme consists of three colors, chosen from the following: blue, red, yellow (gold), green, off-white and the various earth colors. When you use more than three colors it becomes more difficult to effectively use a balanced color scheme. On large objects, such as a cupboard or a trunk, you can use four colors, if needed or desired.

Look over the list of colors and decide on three. I tend to love blue so I will chose that with red and gold.

A background color must be chosen as your rosemaling colors are ALWAYS affected by your background color. An easy background color to work on would be a creamy ivory. I will plan my palette for this background color. To really benefit from this and have a reference later, you should paint out a piece of posterboard with this color. Paint your samples out on this and you will have a good guide for further work.

My palette set-up is done in values. The top line across is the darkest value, for example: Dark Blue. The middle line is the middle value, eg: Medium Blue. The last line is the lightest value, eg: Light Blue. Be sure to have enough contrast between these values. It is easy to get the light blue too dark—it needs to be light enough to show contrast.

1. BLUE—Prussian Blue is the rosemaler's blue of choice. It has a slight greenish tinge so adapts easily to rosemaling backgrounds. It is also easily toned with almost any earth color without losing its identity or turning into mud. On the Ivory background color the blue shouldn't look too greenish so I will mix it with Burnt Umber in equal parts. (A reddish-yellow like Burnt Sienna turns Prussian Blue green, the addition of Black turns it grey).

Blue is lightened by Titanium White to achieve middle and light values.

(Red or green are changed by white into different hues, which are not desirable in rosemaling because of their pastel qualities.)

2. RED—English Red Light (Red Earth) is already a middle value so you will put it in the middle slot. Red is NEVER lightened with white—the dread pink, ufda—you will lighten it with your gold, which in this case is Yellow Ochre (yellow oxide). The dark values of red that we have available are Alizarin Crimson, Burnt Sienna and Burnt Umber. We know that Burnt Umber and Burnt Sienna are earth colors and can be used alone, but Alizarin Crimson (or Burgundy in acrylic) is too bright to use alone. So the best choice for a dark red might be Burnt Sienna.

3. GOLD—we have Yellow Ochre (Yellow Oxide) or Raw Sienna. Look at the swatches of color, or paint it out yourself. If you are painting with acrylics, you can mix YO and RS together to get a good color. In oils RS alone may be best. The dark value for gold can be Burnt Sienna. The light value will be a mixed color that we shall call Putty. Putty is White mixed with Raw Sienna OR Yellow Ochre and is lighter than gold. It is a versatile color that is also used for outlining. I will use Titanium White, four parts; and Raw Sienna, one part; to mix Putty. For darker value backgrounds this color should become progressively darker. To darken Putty you can use Raw Umber. On black it should look mellow and old.

This is a complete palette for our scrolls and flowers, for our outlining or overlay we will also need a dark value. The general rule in Telemark is to have two values for outlining, we'll use Putty and Burnt Umber. (You could use Dark Blue, Burnt Sienna or Raw Umber, depending on the background color.)

This gives you an idea of how to approach the color mixing for each piece that you paint. Of primary importance is the effect of your background color on your paint. Trial and error and mixing practice are very important for you to develop your own eye for correct color.

There are other colors which will be described in the lessons on Color mixing and the individual projects, this is a good place to start.

LESSON FOUR - DESIGN SEQUENCE

Whenever scholars discuss Norwegian rosemaling you hear words like rhythm, movement and flow. The Telemark style creates a movement throughout that uses the design elements of line, value, form, color, shape, variety and rhythm in ways you seldom see at one time in other art forms. In the hands of a master painter the freehand Telemark style is totally dazzling. Like the old masters, a modern master like Sigmund Aarseth can impress even the jaded audiences of old Norwegian wiseacres.

If you want to be one of those dazzlers—and who wouldn't? you have to learn a few basics. They aren't too difficult, but they are important. Read through these first, so that you can get this whole sequence into your design memory banks—yes, you do have them, and one day you will be able to dip into that account!!

DESIGNING A PIECE

When contemplating painting a piece there are several approaches to make: See *.
A) a central scroll design
B) a central floral design
C) various border and corner designs, with or without A or B.

A) CENTRAL SCROLL DESIGNS

1) Always start with the C scroll, it can face either way.
2) Use two strokes on each scroll to give strength.
3) Do a couple of supporting scrolls in the same color.
4) Establish where the primary root is, you don't have to paint it.
5) Add C and S scrolls coming into the primary root area, any color.
6) Watch your "Y" or "V" area in the scroll splits, are they smooth and even?
7) Think about or sketch in flower placement, make some stem lines
8) Outline scrolls
9) Add more scrolls coming into secondary roots (scroll ends)
10) Paint flowers. Scrolls can be added coming out of the flowers if needed.

11) Outline everything else and do fillers and teardrops as needed.
12) Remember negative space!

B) CENTRAL FLORAL DESIGNS

A design can also begin with a central floral motif with scrolls or smaller flowers coming out of the center flowers. This design sequence is similar to that above except it starts with a central floral design. This can be one large round flower or an overlapping design of several flowers. From this design can come scrolls and from these more flowers. This design type works really well in the center of small round plates, or small boxes. It is a little easier in that all of the strokes are shorter and easier to complete than the long scroll strokes.

C) BORDER OR CORNER DESIGNS

You can design a border or a corner design with either scrolls or chains of flowers. This can be a frame for another design in the center or it can be a design that stands on its own.

***JUST A REMINDER —
BACKGROUND COLORS AND THE WAY YOU BASE COAT YOUR PIECE IS A PRIORITY.**

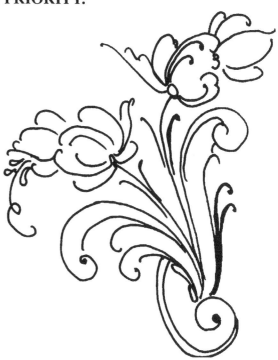

LESSON FIVE - DESIGNS FOR SHAPES

This is a fun exercise. You can draw any size or manner of shapes on sketch book paper. I like Grumbacher 7192 All Purpose Sketch Pad, kid finish, in about 11" x 14". Draw a couple sizes of circles, a horizontal shape, a vertical shape and a square. This will give you lots of different sizes to work with.

Use a pencil or even crayons in several colors to sketch with. Follow the design sequence as listed on the pre- vious page. Look at some of the ideas I have given you but also feel free to improvise.

Secondary scrolls should be slightly smaller than the first scroll. I often find that getting the first scroll drawn (or painted) in an adequate size and shape is by far the hardest part of the whole design. After you have done sketches on all the shapes, it is time to paint. Sometimes you can paint in your drawn designs, sometimes try to paint them freehand.

Remember, this is just for your own development, not for the Smithsonian. Let yourself be fairly free and don't repair anything until you are all done. Then go back over your designs with a colored pencil and correct the shapes and lines. Your design skills will develop twice as fast when you begin to sketch and think design.

You can learn a lot by studying designs by the Old Masters, Nils Ellingsgaard's books have some exciting pictures of old pieces and also Vesterheim has color photos of old rosemaling in its Rosemaling Letter each June. Several of these are available from past years.

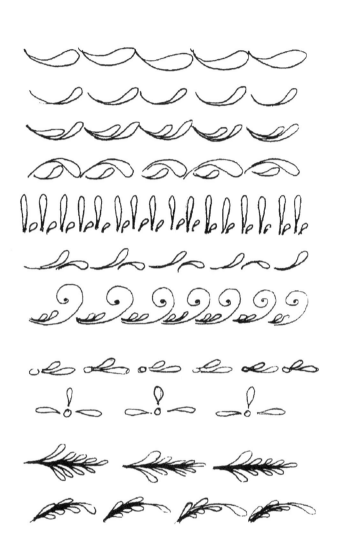

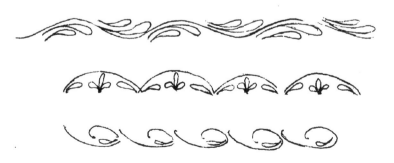

15

Borders from inside back cover

LESSON SIX - DETAILS AND OUTLINING

In Transparent Telemark the real definition of shapes comes from outlining. Some rosemalers outline nearly every stroke, but it looks better if the outlining is varied—some strokes outlined heavily, others with a fine line—strokes that have well-defined edges can be left plain.

It is the ebb and flow—the musical rhythm of Telemark outlining that set it apart from other types of rosemaling. The Telemark rosemalers were absolute masters of the brush. And the more YOU practice the better YOU will become—you have a chance to develop a style that is uniquely your own. Keep your lines short, rather than long. The only lines that need to be fairly long are the ones around the main scrolls and the stem lines leading to the bigger flowers. A long line is not only difficult but is usually uninteresting. A short line intersected by teardrops, followed by another line is much more interesting.

To practice the longer lines you must place your hand fairly far back on the brush. Use your opposite hand to support your painting hand, and place your hands where the line is going to **END.** Wherever your hands are placed, the line will end anyway since you can't paint under your hands. The liner brush should be drawn **TOWARDS** you so that it follows the direction of your hand.

Lines should be thin-thick-thin for variety and rhythmic flow. Each shape should be outlined in a way that shows a personal interpretation—and yet stays within the correct movement of the design.

All linework comes from the root, follows through the scrolls, travels up the stem lines through the flowers and out into the detail work. Like a plant, there are no oddball growths at weird angles.

A line can be and do many things: it can be an outline, it can give direction or move your eyes throughout the design, it can start or stop, be thick, thin, curved, straight or diagonal. A line tells a story in the hands of a Master rosemaler. The old painters always had personality in their vivid, exciting lines. To develop and show your style you need to be a playful manipulator of the brush. You are trying to create an interpretation that is uniquely yours—your personality and style must come through.

Things to remember:

1) Always load the brush fully up to the ferrule with thinned paint, (thin to the consistency of melted butter using oil or water).
2) Always pull the liner brush towards you. The only time it would move away would be when painting a circle.
3) Always use the brush straight up and down for lines.
4) Twist the tip of the brush on the dry paper after loading to begin with a fine line.
5) Use thin-thick-thin strokes.
6) Use shorter lines whenever possible.
7) Variety is more important than rigid, stiff outlining
8) Teardrops and details are often in threes.
9) Details MUST follow through on design.
10) Linework does NOT have to follow the exact edge of the previous strokes, it is more interesting if it produces its own design of C and S curves.

EXTRA PATTERNS

LESSON SEVEN - BORDERS

It is important to remember that every piece of rosemaling needs some type of border, it can be just a line, a band, a complicated floral border, or lettering. Some type of border needs to shape the edge of the rosemaling to contain the circular energy of the design and enhance the colors.

By planning for a border in the very beginning, you can more easily plan your painting also. You can cut down on the area in which you will have to paint, which often enhances the design that is there by simplifying the piece.

FOR ROUND ITEMS SUCH AS BOWLS, TANKARDS, ETC.

Wrap a piece of string around the piece. Measure the string and use a piece of tracing paper the same length. You can do the design as one long segment or you can fold the tracing paper and create smaller segments such as folding in half will give you two, folding into quarters can give you four repetitions. The shorter repetitions seem easier to me. Often you may have to fill in a section with a couple of teardrops—this is pretty common and don't worry about it—this shows it was hand painted!

NOTES ON BORDERS:

1) Use design elements from your painting.

2) Use the same palette colors (if the inside is painted orange and the rim is painted blue you may have to adjust your colors slightly so they aren't too bright).

3) Use Gold somewhere if possible. There should be a "touch of sunshine in every border." (Nils Ellingsgaard) This does make a happier looking piece!

4) Don't have any big spots of dark or light—squint to see value.

5) Keep your design elements in the same family. If you use dot flowers in the border and there are none in the design it will look like it doesn't match.

6) Don't distract or detract from the main design. Borders should be much quieter or less bright than the design. Toned—or you can antique with a thin glaze later.

DESIGN ELEMENTS YOU MIGHT USE— you may think of some of your own also, these are just suggestions—sketch and experiment! See inside back cover for color borders.

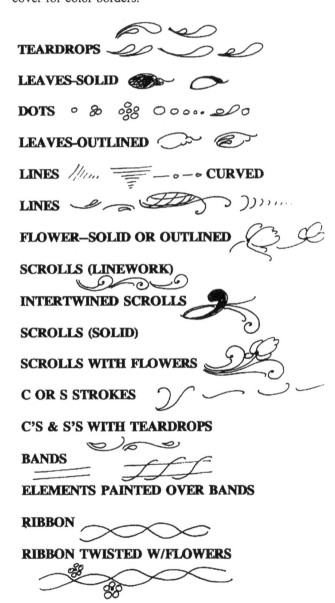

TEARDROPS

LEAVES-SOLID

DOTS

LEAVES-OUTLINED

LINES ///..... ≡ —o—o CURVED

LINES

FLOWER—SOLID OR OUTLINED

SCROLLS (LINEWORK)

INTERTWINED SCROLLS

SCROLLS (SOLID)

SCROLLS WITH FLOWERS

C OR S STROKES

C'S & S'S WITH TEARDROPS

BANDS

ELEMENTS PAINTED OVER BANDS

RIBBON

RIBBON TWISTED W/FLOWERS

LESSON EIGHT - BACKGROUNDS AND COLOR MIXES

COLORS I USED IN THIS BOOK ARE IN BOLD

OILBASE: semi-gloss or low lustre enamel from Sherwin Williams (SW) or Pittsburg Paints (PP);

ACRYLICS: JoSonja (Chroma) (JS), Decoart (DA) or Delta (D)
Oil base color names are listed first, then acrylic equivalents.

1. TELEMARK WHITE (greyish) Sidewalk (SW), Smoked Pearl (JS), Antique White (DA), Sandstone(D)

2. CREAMY TELEMARK WHITE
Old Parchment (PP), Warm White +tch. Yellow Oxide (JS), Yellow Ochre + White (DA), Old Parchment (D)

3. RED-ORANGE (Nils Red)
Georgia Clay (PP), Norwegian Orange (JS), Georgia Clay (DA), Georgia Clay (D)

4. RUST (Valdres Red)
Really Rust (PP), Burgundy 1 pt, Gold Oxide 2 pts (JS), Red Iron Oxide (DA), Red Iron Ox(D)

5. DARK RED
Brick Red, 20-200 base. B-17, F-2y + 6, W-6 (PP), Indian Red Oxide (JS), Deep Burgundy (DA), Burgundy Rose (D), Napa Red (DA)

6. GOLD
Eagle Cave (PP), Yellow Oxide + tch. White (JS), Raw Sienna (DA), Raw Sienna (D), Sand (DA)

7. NORSK BLUE (Med. Blue-Green)
Cosmos Blue (PP), Sapphire 2 pts, Teal Green 1 pt. (JS), Williamsburg Blue (DA), Norsk Blue (D)

8. SKUGGA BLUE (Dark Blue)
Midnight Blue (PP), Storm Blue (JS), Midnite Blue (DA), Midnight, Dark Night (D), Nightfall (D)

9. IS BLUE (Light Blue Green)
Take Blue (SW), Smoked Pearl 5 pts, Teal Green 1 pt (JS), Heavenly Blue (DA), Salem Blue (D) (This color is usually antiqued)

10. NORWEGIAN BLUE (grey-blue)
Indigo Blue (PP), French Blue (JS), French Grey/Blue (DA), Fjord Blue (D). Add white for a lighter value of these.

11. SKUGGA GREEN (Dark Telemark Green)
Midnight Green (SW), Dark Forest Green (PP), Pine Green (JS), Hauser Green Deep or Midnight Green (DA), Dark Forest or Gamal Green (D)

12. TELEMARK GREEN (med. green)
Salem Green (PP), Teal Green-2 pts, Raw Sienna-1 pt(JS), Deep Teal (DA), Salem Green (D)

13. NISSE RED (Christmas Red)
Tomato Spice (PP), Napthol Crimson (JS), Tomato Red (DA), Tomato Spice (D)

14. DEEP TEAL BLUE-GREEN
Woodland Night (PP), Sapphire 2 pts. + Storm Blue 1 pt (JS), Deep Teal(DA), Woodland Night(D)

15. BLACK
Soft Black (DA) a brown black

(Oils-You may have to paint out a swatch of acrylic color to take to your local paint dealer. Be sure to specify satin, low lustre or semi-gloss enamel. Use carefully in a well ventilated room—do not paint with oil base paints in a small apartment. Remember the fumes can be quite powerful and will be OVERwhelming in a small place. ALL varnishes are to be used with the same amount of care. The fumes are strong. ACRYLIC varnishes and sealers are also strong and can make you sick so use everything with care and lots of ventilation. When basecoating and varnishing furniture it is best to use a workshop, garage or a separate room that can be closed off from the rest of the house. Use a respirator if you feel any reaction and take frequent breaks. Don't keep your paints and brushes in your freezer or refrigerator, especially if you have young children. Use common sense even if it's odorless!)

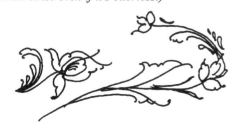

load with gold-
tip in red.
press down

"5"

press
lift to
chisel

point

1

2 3

press

twist, lift

Chisel →
press →
fully →
lift to chisel ↗

press
twist
lift

to
right

Chisel
press- lift

2 to
left

lift towards
center of flower

do leaf in one stroke — or —

press, twist
and
lift into "S"

pull flower
strokes from
stem
end.

© Edwards

Use a size 4 flat or filbert.

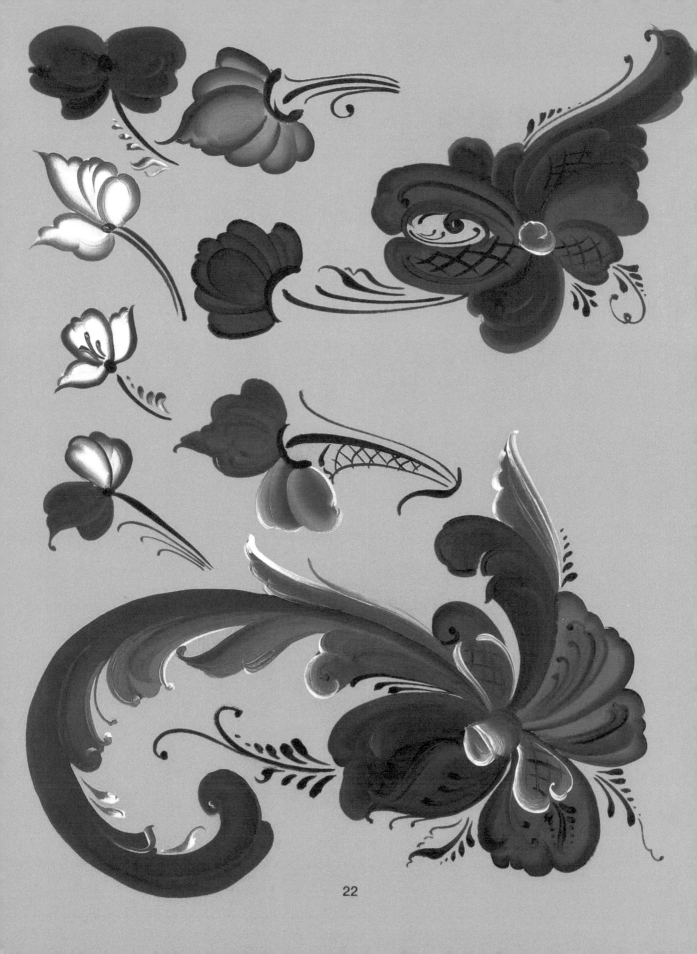

22

VELKOMMEN BOARD/SHELF

(Photo - front cover • pattern - page 33)
SOURCE: CabinCrafters
BKGD: Deco Art Blue Haze, Antique White Measure out 1/2" from the inside of the frame for a band of Blue Haze inside.
METHOD: Trace design.
COLOR:
Dark Blue--PB + BU = pts
Med. Blue--Dark mix+ TW Off White--TW + Tch BU
Gold--Yellow Ochre
Red--Trans. Red Oxide (TOR)

Using a Size 8 Filbert paint in the center C scrolls and outside S scrolls. Wipe off your brush and load with the Medium Blue and finish scrolls. Clean brush and load with Off White and paint in White scrolls and outside of flowers. Clean brush and load with Yellow. Paint in Yellow scrolls, centers of flowers. Wipe brush and load with TOR and finish flower centers.

Outlining color (O/L) is the Medium Blue with a little White added.

Paint lettering with TOR with a size 4 Flat brush. Use a touch of Oil just enough to make color flow. Flatten brush carefully on each side to keep a nice chisel edge. I like to use a new brush for lettering, if there are any bristles sticking out it will be hard to do.

Glaze edges with Dark Blue mix and pat for texture.

SCISSORS HOLDERS

SOURCES: Black, R & M Wood Knots, Blue, Waynes Woodenware
BKGD: DA Soft Black, Delta Blue Haze, Antique White
BRUSHES: Size 6 Filbert and Size 4 Flat. Size 1 Script.
COLORS:
Dark Blue--PB + BS = pts
Med. Blue--Dark mix + TW
Off White--TW + Tch BU
Gold--Yellow Ochre
Red--English Red Light
OL/Putty on Black, Dark Blue on Antique White and Off White.

METHOD: Start with C scrolls with Dark Blue, gradually lighten blues as you go. Wipe your brush and get more White on to lighten strokes. This technique gives your an automatic dimension to your scrolls.

The secret is to wipe your brush off--don't clean it-- and continue to finish scrolls in one sitting if using acrylics. The Blue is mixed to match the Blue Haze-- it also works on the Soft Black. Notice that the English Red Lt. looks much redder on the Blue background, and oranger on Black.

BLACK SCISSORS HOLDER

(Photo - back cover • pattern - page 37)
After the Blue is painted I used the Yellow Ochre occasionally touching the tip of the brush in Off Whit . This gives a little dimension to the top of the stroke. Wipe the brush and load with ERL and finish filling in the strokes. Scroll-type strokes are pulled down to the root. Small decorative C strokes are pulled FROM THE ROOT out. These are short strokes that are fillers.

On the Black piece notice the small white C strokes on the left side of the top C scroll. This is a good example of the strokes that are pulled OUT. I turn the piece upside down to do this so you are pulling this stroke TOWARDS you out from the root.

BLUE SCISSORS HOLDER

(Photo - inside front cover • pattern - page 37)
After finishing the Blue Scrolls, change your brush and load with White--I use a Size 4 flat for flowers. Flower strokes are pulled from the root so I turn the piece upside down to do the big flower between the scrolls. Outline with Dark Blue. When outlining with acrylics, put a touch of JS Flow Medium in your Overlay color to keep the paint from looking too hard. With oils you get a natural softness due to the wet paint, but to avoid a hard starting line you can touch your liner brush point in the color you are outlining over. This gives a much softer appearance to the piece.

METAL HEART PLATE

(Photo - front cover • pattern - page 38)
BKGD: DA Soft Black
SOURCE: BarbWatson
COLORS: Greenish Umber, Transparent Oxide Red, Transparent Oxide Yellow + a touch of TW, English Red Light and Putty.

Note: Use a large soft brush for backgrounding so as not to leave brush marks. Linework on this metal is so easy and flowing--it's much easier to work on than wood.

Trace designs on very lightly so that the lines don't show through the transparent paint. Start with the Green leaves, these are simply stroked on and then outlined with Putty. Next, paint the TOY + W strokes, touch into Putty and paint in center strokes. Red is painted in the center of the left flower. Outline all strokes before painting in the center flower with TOY and a Red center.

Outside scrolls are started with TOR. As strokes move in add a touch of ERL and then Yellow + W. Follow the colored photo and paint in bottom flowers. Outline all with Putty.

METAL COASTERS AND SQUARE PLATE SET
(Photo - back cover • pattern - pages 34-36)
I thought this would be a nice little tea set for a friend's visit.

BKGD: DA Soft Black
SOURCE: BarbWatson
COLORS:
Dark Blue--Prussian Blue + BU = pts. Med. B-l part DB to 4 pts White. Dk RTOR, Red-ERL, Gold-YO. Off White-TW +tch BU.
BRUSHES: Size 4 Flats, Liner

PLATE: All the scrolls were painted with Dark Blue and then followed with M. Blue. YO was then painted on top gold scroll and small flowers. Touches of ERL are painted next, followed by strokes of Off White. Outlining is all Putty. Notice when pulling through wet Blue that Putty also becomes blue. This is good because it unifies the design--when painting with acrylics you might want to add blue touches to keep this unification.

Borders on all are stippled YO (use a little oil) and Putty linework into wet YO.

COASTER #1
Three petal design is started with BU strokes. Paint in a crescent stroke. Inside is Off White and then Yellow Ochre. Scrolls are TOR followed by ERL on inside strokes. Outline Putty.

COASTER #2
Flower design starts with Dark Blue, wipe brush and add M.Blue. Orange is TOR + YO, brush mixed. Wipe brush and paint YO last. Outline Putty.

WOODEN COASTERS
This is a good project for practicing small designs, its a little easier to keep your fingers out of the paint!!
SOURCE: R & M Wood Knots
COLOR MIXES:
Dk. B-PB + BU = pts. M.Blue-D + W. Off White--TW + tch BU, Gold = YO, R-ERL, Rust-BS, Putty = TW + tch YO.
BRUSHES: Size 4 and 6 filberts, Size 1 liner

#1 Delta Norsk Blue
(Photo - inside front cover • pattern - page 35))
Scrolls-Dark Blue, go through M.Blue to Off White. Flowers are Yellow Ochre, Burnt Sienna and Putty. Outline with DB.
Edges are DB.

#2 Deco Hauser Dark Green
(Photo - back cover • pattern - page 39)
Scrolls are DB, edged with MB. Side S strokes are YO, C strokes are ERL. Darker Rust is BS edged with ERL. Outline with Putty. Edges are DB.

#3 Deco Antique White / Blue Haze
(Photo - inside front cover • pattern page 35)
Scrolls are DB, Flowers in center are BS, other florals are YO edged in BS. Blue florals are edged in Lt. Blue. Edges are Delta Blue Haze.

#4 Deco Deep Burgundy
(Photo - page 42 • pattern - page 35)
Paint smaller flower first. Start with D.Blue, wipe brush and load with M. Blue and paint both side petals, moving to the middle and painting the white petal last. The bigger flower starts with the Gold petals, wipe and load with Putty. Using Blue brush finish Blue petals. To go from Dark to Light values just wipe your brush off and tip in light, then wipe and tip in dark. Outline with Putty on outside and DB in the center. Tip some Putty teardrops with DB.
Edge is M. Blue.

#5 Deco Napa Red
(Photo - back cover • pattern - page 36)
Glaze over the whole piece with JS Red Glaze. This gives a lot of depth.
Start in center with four BS petals. Use C strokes with Gold outside of BS. (Center is left Red and then cross hatched with Dark Blue.) Linework around the flower is Putty. Outside flowers are Blue and BS alternating. On Red backgrounds your Blue mix should tilt towards Green. IF it looks too blue you can brush mix in a touch of BS which will make it greenish. Outlining on outside florals is DB.

EIGHT INCH BLUE PLATE
(photo - inside front cover • pattern - page 44)
This is an easy project for classes. It is small and a fairly simple design. Also, students paint better on flat pieces.

BKGD: Deco Blue Mist, Glazed on edges and rim with JS Blue Glaze. Center bead is Deco Red Iron Oxide. Float a thin coat of Blue glaze over it and immediately wipe off the top edge.

COLORS:
B-PB + BS = pts. Off White is TW + touch YO. Gold is YO, Red is ERL

First, paint scrolls with Blue, wipe brush and load with OW. Flower is Gold strokes, paint it by turning plate upside down, Center is OW and it has ERL scroll on top. Side strokes on the bottom of the scroll are Gold strokes edged with Red. These are painted from the outside in. A short stroke and three longer ones without reloading the brush. Follow color photo for color placement--you are only looking for color balance. Outlining on Blue is Off White, all other is Blue.

Border is just alternating Gold and Red flowers with Off White linework. Do center stem first and then long S stroke down the right side. Be sure all these lines come from the root of the flower below. Try not to spread them out too far. These long teardrops are good practice material! Keep them from touching each other. If teardrops are hard for you, you could outline a leaf shape on the left side of the stem.

TEN INCH NORDIC RIM PLATE
(photo - page 42 • pattern page 46)
SOURCE: Wayne's Woodenware
BKGD: Center Deco Sand painted through the bead. (Bead is painted with YO). Deco Tomato Red on Rim and Bead. Bead is then painted with Med. Blue.

COLORS: Dk. B-PB + BS = pts. M.Blue is Dk + TW, Lt. B is M + W. Gold is YO + RS = pts. Red is T.Red Oxide on center and ERL on rim. Center should match Tomato Red on border, if it doesn't, I would add a little ERL to TOR. Outside Bead is painted with M. Blue.

METHOD: Paint center Blue scrolls with M.B. Add DB in to center. Gold scrolls go into White. Red Flowers go from Dark to Light--Red through Gold to White. This gives dimension to the flowers. Look at color photo to see color placement. Outside flowers are light Blue mix, going into white. Outside petals on these are TOR. Outlining is with Light Blue and Dark Blue.

Rim is simple flowers that just alternate going around so this design can fit on any size plate. You can trace these on or just measure the rim into quarters and make a chalk mark to make them fit. I then alternated the stems--first is one going in, the next stem turns out and then I just place the teardrops on the convex side and the linework on the concave side. Keep it simple! I used Light Blue linework on the Rim occasionally tipping it in the Dark Blue. Flowers are Gold and ERL on the one side and Dark Blue edged with TOR on the other.

The center Gold bead is patted with TOR on top of the Gold while it is still wet.

BREAD BOARD
(photo - front cover • pattern page 43)
I love this breadboard which I purchased From Heather Redick from Canada. I painted three of them before I decided on this one! Having been raised on a wheat farm I could appreciate this beautiful wheat design. Since this is carved into the outside rim, it could be rubbed with a touch of Gold for an extra accent--I feel it's a very Norwegian looking design and a wonderful gift. Finish the back with Mineral Oil so it can be used as a cutting board. Varnish the front with many coats of Right Step Varnish for a beautiful finish.

BKGD: color of center and edge is Delta's Nightfall. Edge and "Bread" strip are stained with Linseed Oil and Liquitex Oil RU. The center is not stained. Be careful not to get any paint on the stained area--you can't remove the acrylic from the raw wood very easily.

COLORS: I wanted a dramatic statement so I used strong colors. Dark Blue is PB + BU = pts. M. Blue is DB + TW. Don't get this too light--just a little lighter than Nightfall. Outline these with a blue that is just one value lighter than Med. Blue. Flowers are TOR, edge with ERL. Gold is YO + RS =pts. Lighten this with Off White. TW + touch of BU. As you can see by studying the color photo I rarely totally clean my brush. This brings the colors throughout the design and provides much more unity and color relationships are better.
I wanted this design to be very flowing and organic looking like the wheat design on the rim.

BENTWOOD BOX
(photo - inside front cover • pattern pages 39 & 40)
SOURCE: Valhalla Designs
I love everything that Ceal and Bob Perry make, it's hard to just pick one piece! Wonderful Norvegian Wood!

This box has a wonderful Norwegian edge that makes it so graceful. I decided not to paint it but to just enjoy its design shape.

The rest of the design is fairly simple, but painting around a box is never easy. I like to put my left hand in the box and paint all the strokes. When it comes to linework however you must set it down and just take your time. Since I paint in my lap I put the bottom of it on my left knee and work around that way. Fun!
BKGD: Deco Blue Mix with Delta Blue Haze on the edge. You need to chalk on a line for the edge of the top and mark one about 1/4" from the bottom to keep the design from going off the bottom. Paint a line or an edge on the bottom to set the box down.
COLORS: PB + BU = pts. Mix three values, M and Lt. with White. Off White is TW with a touch of BU. Red is TOR. Coral is TOR plus a touch of BS plus White to get a nice salmony color NOT PINK. I wanted the colors on this to be fairly light and airy therefore lots of Off White.

Start with Dk. Blue scrolls going through values to the White. All flowers are Coral edged with TOR. Bottoms of flowers have White strokes, Everything is outlined with Medium Blue--just a value darker than the background so it isn't too busy, If this box is used for food you can just use a wax inside or, if using a water based varnish let it set for a couple of weeks to outgas so you don't get a taste in the spritz!!

OIL LAMPS
SOURCE: Western Woodworks.
These are handturned by Harry Keller--a beautiful product. I had a tabletop next to them at the first show they ever did and it sure is fun to see how popular this work has become!

SMALL OIL LAMP
(photo -inside front cover • pattern page 36)
BKGD: Deco Antique White. Top edge and bottom are stippled with Med. Blue. Colors are: PB + BU = pts, M.Blue is DP + W. Gold is YO + RS = pts, Red is ERL. Overlay is Dark Blue. White is TW + touch BU.
METHOD: Paint D. Blue scrolls all the way around and then wipe brush and add M. Blue. Flowers are added last in Reds Golds and Whites. Work for color balance and don't worry about where to put what. Paint edges last when the rest is dry if possible.

LARGER OIL LAMP
(photo - page 42 • pattern page 35)
Bkgd is Deco Deep Burgundy . Colors are the same as above except I used no Red. There is occasional outlining of all three values of Blue as well as Gold here and there. Work for color balance. When I paint, I don't plan color placement too strictly, the piece must be studied as to where you need to add certain colors. Sometimes it's obvious and sometimes you need to ask your hubby or a friend--what's missing?? A fresh eye can often pick up on something you can't.

SMALL CLOCKS
SOURCE: These wonderful clocks are from The Wizard of Wood--and believe me, they are Wizards! This is a small sampling of the beautiful work they do-it's hard to decide which to buy! But do look for something with enough painting surface. They have beautiful cut-outs that are art forms in themselves! Be sure to buy the clock works at the same time you buy a clock. I have more clocks and more works that don't match, (from different dealers--some dealers don't have return policies or batteries--what a hassle). Wizard of Wood are great people to work with.

RED CLOCK
(photo -page 42 • pattern page 28)
BKGD: Deco Tomato Red, Glazed with JS Red Glaze, two thin coats. I painted this thinly to allow the beautiful wood to show through.
COLORS: Same as for Oil Lamps.
I used three values of Blue on these scrolls and the molding is painted with the blue on the bottom. The flowers are Gold in the center and Off White petals on the side. Overlay is all three shades of Blue.

ANTIQUE WHITE CLOCK
(photo -inside front cover • pattern page 27)
BKD: Deco Antique White all over and then edge is painted with Deco Blue Haze. I glazed over this with JS Blue Glaze with a touch of JS Yellow Oxide Glaze added to make it greenish.
COLORS: Are same Blues as Oil Lamps, Golds and Burnt Sienna in the center of the flowers. All Overlay is the three values of blue. (You may notice that when you paint with oils you can paint several projects at once. You can also do this with acrylics if you plan ahead with backgrounds that are similar and use a wet palette.) I am a lazy paint mixer--why not paint several things at one time and keep it simple? You must watch your blues when you do this--don't use the wrong blues-other colors are not quite as important.

SMALL CLOCKS

GREEN CLOCK: Delta Woodland Night.
BLUE CLOCK: JS French Blue.
COLORS:
Same for both. Mix Blue for the French Blue. Dk. B-l
pt. PB + 3 pts. Ivory Black Md. Blue-DB + a little
White. (If this is too bright add a little more black to
the Dark Mix and re-test.) Always test your Blues on
your background color and check in a couple light
sources. They should look like they are of the same
family not a Black Sheep!
Gold: YO + RS = pts. Dk. Red is TOR, Lt. Red,
CRL. Putty is White with tch Gold mix.

GREEN CLOCK
(Photo - back cover • pattern - this page)
Paint little leaves around flowers with Dark
Blue touched into Gold. (I use a Size 4
Filbert--you may want to use a Size 2. This
is the time to get out a new brush--old
brushes don't paint leaves!!)

Paint Gold scrolls next and touch them occa-
sionally into Putty. Flowers: Red flower is
painted TOR and then edged with CRL. Paint
from the center out. Next paint the Gold flower
Burnt Sienna and then edge with Gold and then
Putty. Blue rose is last. Paint it in with Dark Blue.
Wipe your brush and load edge with M.Blue and then
White, These flowers are painted on the flower sheet
so you can see the stroke progression. Overlay and
outline clock with Putty.

FRENCH BLUE CLOCK
(Photo - inside front cover • pattern - page 28)
Scrolls are Dark Blue, followed by M. Blue. Wipe
brush and edge with White for strokes up the back of scrolls.
Outlining is all Putty. Flowers are Gold, Dark Red and CRL
blended next to the dark. The Heart on top is painted with
Dark Red on one side and CRL on the other. Blend down
between colors. Top scrolls are Gold and as you go down
pick up Putty to lighten. Front piece of clock has small
Dark Blue scrolls, outlined with Putty and Putty cross
hatching. Be careful on the clocks not to paint too close to
the dial so when you put the clock in it doesn't cover your
painting-this almost requires a few chalk marks--hard to stop!!

SMALL HEART PEG HOLDER
(photo - page 42 • pattern on page 29)
SOURCE: Drake Distributors
BKGD: Deco Tomato Red Glazed with JS Red Glaze
I love Red and I loved this heart, it almost feels carved and
has such a pretty look.
My kitchen has Red and I needed something to hang my
oven mitts from. I didn't really want to paint much on it so I
just used a little border.

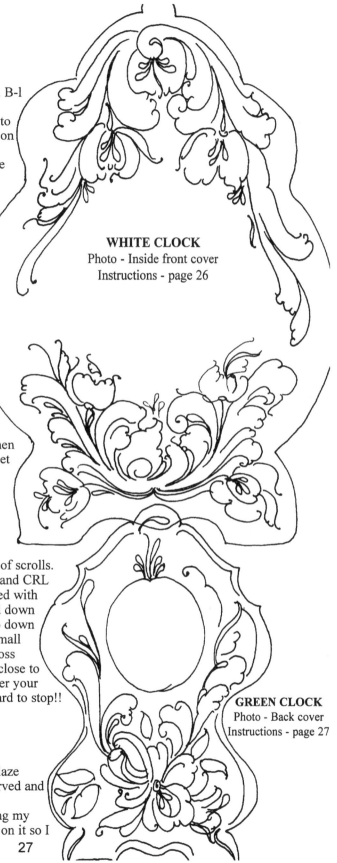

WHITE CLOCK
Photo - Inside front cover
Instructions - page 26

GREEN CLOCK
Photo - Back cover
Instructions - page 27

27

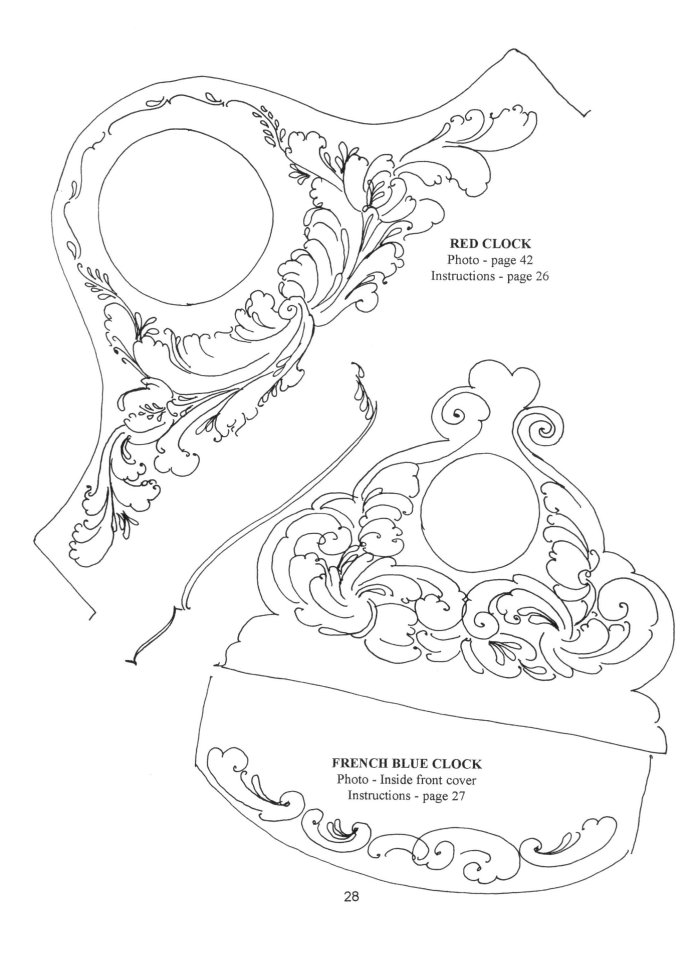

RED CLOCK
Photo - page 42
Instructions - page 26

FRENCH BLUE CLOCK
Photo - Inside front cover
Instructions - page 27

LARGE GREEN WALL CLOCK
(photo - back cover)

WALL CLOCK
Repeat to make complete
pattern
Trace and flip over for reverse.

SOURCE: Quartz Concepts
BKGD: DA Midnight Green
COLORS:
Dark: Greenish Umber,
Med: GU + White,
Gold: Yellow Ochre,
Red: Venetian Red, O/L: GU + TW.

Each design section is traced on separately - leave a half inch or so between - adjust to fit the space. I repeated this 10 times. (You can reverse the pattern if it fits an even number of times.)

Start with a size 4 filbert and the Dark Green. Do two or three strokes on each side with DG and then touch the brush in the Med. Value Green & continue down the scrolls on each side. Wipe the brush and load in YO. Do one stroke on each side and load with Venetian Red and do one stroke on the outside of the scrolls. (See photo) These can alternate if you have even numbers of pattern pieces. Outline with GU & TW and fill in the space between with crosshatching.

LAZURING
Krilling and Antiquing

Lazuring (which means glazing in Norwegian) is an important part of the look of Norwegian rosemaling.

Lazuring a toning of the background color by using a thin veil of transparent color. This gives beautiful depth and color to your rosemaling. Most pieces just are not complete without this added step.

SMALL HEART PEG HOLDER
Photo - page 42
Instructions - page 27

The Aarseth-Miller book (see Bibliography) gives some insight into lazuring and how to do it. I usually use a slightly darker value of the background color . On lighter color backgrounds such as Old Parchment you can work in a touch of any of the colors on your palette-Raw Sienna works very well. Use just a little color--and only the transparent ones that don't obscure your background. One can paint wet-into-wet on the oil lazuring -- but if you are worried about making mistakes, let it dry and then give it a very thin coat of varnish before painting. The rosemaling usually doesn't stick onto the lazuring glaze--it beads up. If this happens you can use oil base varnish for a medium.

Krilling is the creation of patterns on your background with wet paint on the background color. A common pattern used a cut potato twisted into the wet paint. a comb, rags, or fingers were often used. This is not usually rosemaled on, but used for decorative purposes.

For oils use Gel and for acrylics use JS Kleister medium. Antiquing--to give depth and edges to the pieces - not an all over covering. A darker, transparent color would be used with a little oil.

ACRYLIC LAZURING

Paint on a thin coat of retarder with a large brush (very important-no water!). Keep it loaded lightly with retarder. Touch a corner of it into your paint color. Apply this wherever you want a darker area, blend well with a mop brush when finished. I like to paint wet into wet to achieve an oil-like look, but if you feel more confident on a dry background, you may dry this with a hair dryer before starting your painting. Keep the retarder thin so you don't end up with runs and puddles. Stretch the retarder out as you apply it, and wipe off gently.

OIL LAZURING

Brush or rub on a thin coat of Linseed oil. Touch a brush or a cloth into the paint. Apply onto areas where you want shading. Keep the lazuring as thin as possible and avoid runs or drips of oil. Place darker shading in areas that can be developed for depth such as edges, beads, carving or interesting areas. Shading the edges of pieces gives your painting a natural frame which really enhances the painting. The shading should lighten in the center. Don't leave any sharp edges or strong lines. Lazuring is a background treatment--subordinate to the painting, and the base color should show through.

COLOR MIXTURES FOR USE ON DIFFERENT BACKGROUNDS

1. Antique White
a) Green, gold, orange
b) Blues, rusty red, gold
c) Blue-greens, dark orange, off-white

2. Creamy White
a) Deep green, gold, deep red
b) Blue, rust, Raw Sienna
c) Orange, blue green, Burnt Sienna

3. Red-Orange
a) Soft blue, green and off-white
b) Medium blue, gold and off-white
c) Soft green, rust, gold

4. Rust
a) Soft Blue, gold and off-white
b) Deep green, red and gold
c) Dark blue, rust red, gold

5. Brick
a) Soft gold, off-white, blue
b) Medium green, red, gold
c) Medium blue, dark red, off-white

6. Gold
a) Green, orange and off-white
b) Green, deep red and gold
c) Deep blue, orange and Burnt Sienna

7. Norsk Blue
a) Blue-green, rust, Yellow Ochre
b) Dark blue, orange, off-white
c) Dark red, Med. blue green, gold

8. Dark Blue
a) Blue, rust red, ochre
b) Light blue, deep red, Raw Sienna
c) Red, Ochre and off-white

9. Light Blue
a) Dark blue, orange and grey-green
b) Dark blue, deep red and off-white
c) Deep green, soft orange and gold

10. Norwegian Blue
a) Grey-blue deep, rust, gold
b) Dark blue, orange,
c) Dark green, soft red, soft gold

11. Dark Green
a) Dark green, deep orange, gold
b) Soft blue, rust red, off-white
c) Dark orange, soft blue, gold

12. Med. Green
a) Blue-green, rust, gold
b) Dark green, orange, off-white
c) Burnt Sienna, orange, gold

13. Nisse Red
a) Blue-green, orange, gold
b) Dark green, gold, off-white
c) Dark red, light blue-green, gold

14. Deep Teal
a) Dark teal, rust, gold
b) Soft orange, gold, off-white
c) Soft blue green, orange, gold

15. Black Green
a) Medium blue, rust, gold
b) Soft deep green, burnt orange, gold
c) Burnt Sienna, Raw Sienna, rust

NOTES ON COLOR

"**Soft**" means toned with an earth color and a little white added to soften its intensity or brightness. It doesn't mean to make it pastel or weak.

Dark or deep mean the darkest value of that color, without it turning to black. For example, a dark blue could be a mixture of Prussian Blue and Black. To make it show up on a Navy Blue background you might add a touch of White to it.

EDGING OR DOUBLE LOADING is done by loading your brush with the middle value and then edging with either the darkest value or light value for that color. Gold is used for the lightest value on greens or reds, to avoid mint green and pinks. Putty or Off-White is used for all others. Be careful with whites, they can get really chalky and ruin your transparency. A great all-purpose white is Titanium White plus Greenish Umber (an oil paint) it takes on the characteristics of almost all blues and greens. (In acrylics I like to use Brown Earth with Warm White.)

Off-white is usually mixed with Burnt Umber (or you may use Raw Umber which makes a greyer white, or Greenish Umber which makes a neutral blue-greenish tone). Brown Earth and Burnt Sienna get too pink when mixed with White.

Red means Cadmium Red Light (Cadmium Scarlet in Acrylic), which is usually toned with an earth color, except when used for a double-loaded accent or liner accent. Rust means Venetian Red (Red Earth), or CRL plus Burnt Sienna. Orange is Cadmium Red Light mixed with Yellow Ochre equal parts and a touch of Burnt Umber. Or you can use Norwegian Orange acrylic straight or toned with a touch of Burnt Sienna.

Every color can have a dark, middle and light value—dark and light values are used for edging your strokes.

ROSEMALING ON COLORED BACKGROUNDS

Background colors: Left to Right French Blue-JS, Old Parchment-D, Ivory-D, Hauser Dark Green-Deco, Norsk Blue-D, Red Iron Oxide-D or Deco. Remember how brands differ--you MUST test your mixes on YOUR background before painting.

PALETTE MIXES

BLUE on French Blue:
 D-Prussian Blue + Black,
 1 part to 2 parts
 M-Dark mix plus white
 L-Medium mix plus white
BLUE on other bkgd colors:
 D-Prussian Blue and Burnt
 Umber equal parts.
 M-Dark value plus white
 L-Medium value plus white
RED
 D-Burnt sienna
 M-Cad.Red Light plus
 Burnt Sienna equal parts.
 L-Yellow Ochre (Yellow Ox.)
GOLD
 D-Burnt Sienna
 M-Raw Sienna
 L-Putty (RS + W)
RUST
 D-Burnt Umber + Alizarin
 Crimson (Burgundy)
 M-English Red Light (Red
 Earth)
 L-Yellow Ochre (Yellow OX.)
GREEN
 D-Viridian Green, 2 parts+
 Burnt Umber, 1 part
 (Teal Green)
 M-Dark plus Yellow Ochre
 L-Yellow Ochre (Y.Oxide)
OFF-WHITE
 D-Greenish Umber
 D-GU + White
 D-M + White
GREYED OFF-WHITE
 D-Raw Umber
 M-RU + White
 L-M + White
GOLD
 D-English Red Lt.
 (Red Earth)
 M-Yellow Ochre (Y. Oxide)
 L-Putty (White 4 pts + YO)

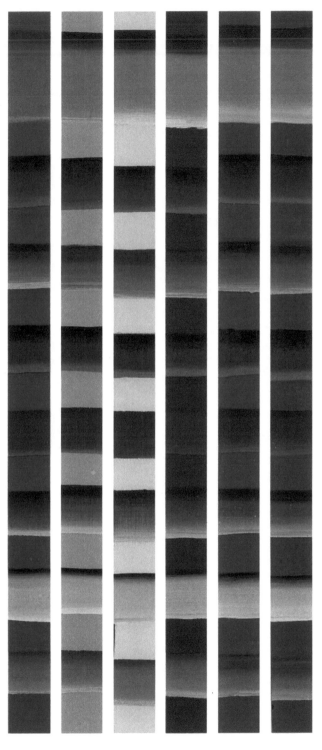

PALETTE MIXES

CHROMA ARCHIVAL oils
unless stated otherwise
Set up your palette with three colors
listed across the top. Draw lines
across the palette to leave boxes for
Dark Mixes across the top, Medium
Value in the middle and Light Value
across the bottom.

 If you always use this palette
set up you'll always know where your
colors are and won't use the wrong
light value--such as White on Red.
(Reds and Greens are usually
lightened with Yellow Ochre. Pinks
and minty greens tints or pastels are
not traditional colors in Rosemaling
and should be avoided. Also, avoid
purples and lavendar shades.
BLUES--You may use greenish or
greyish blues--always experiment on
your background first. Greyed blues
are for blue-grey backgrounds, can be
used on black and off-whites. Blues
tilting towards green
are best on warm backgrounds.
TCS COLOR CLASSIFICATION SYSTEM
from oils for all Acrylics
Black--BK-5-1-9
White--WH-5-1-1
Yellow Ochre--YE-6-4-7
Prussian Blue--BL-5-2-7
Cad. Red Lt--RE-4-1-5
Eng. Red Lt--RE-4-6-5
Burnt Umber--BR-7-6-9
Burnt Sienna--BR-6-2-6
Alizarin Crimson--RE-6-2-8
Viridian--GR-3-5-8
Greenish Umber--YG-5-6-6
Raw Sienna--BR-1-2-5
Raw Umber--BR-8-6-8

Transparent Oxide Red
Yellow and Brown, no exact
equivalents

From: TCS Color Match Source Book by
Bobbie Pearcy, 2nd Edition.
This book will save you many hours
of effort, it is available from:
Tru-Color Systems, Inc.
64 East Marion St.
Danville, IN 46122

Software also available: check them
out on the Internet, (My books are
listed there also).
WEB: http://www.tru-color.com/tru-
color/

Line 1--True Green
Dk--Viridian + BU, 2 to 1
Md--Dk + YO, 2 to 1
Lt--YO
Line 2--Grayish Green
Dk--Rembrandt Greenish Umber
Md--RGU + White = pts
Lt--Md + More White

Line 3--Bright Red
Dk--Burnt Sienna
Lt--CRL + YO = pts
OR Cad. Red Scarlet (Light)
Line 4--Dull Red
Dk--Aliz. Crimson + BU = pts
M--Rembrandt English Red Lt.
Lt--YO
Line 5--Red
Dk-Rembrandt Trans. Oxide Red
Md-Oxide Red Transparent
Lt-Cad Red Scarlet
 OR YO straight

Line 6--Gold
Dk--Rem. TOR or Burnt Sienna
Md--YO
Lt--White 4 pts, YO 1 pt
Line 7--Gold
Dk--Burnt Sienna
Md--Raw Sienna
Lt--TW + RS, 3 to 1
Line 8--Gold
Dk--TOR
Md--Rem. Trans. Oxide Yellow
Lt--TW + TOY

Line 9--Off Whites
Dk--Raw Umber
Md--RU + W, 1 to 3 pts
Lt--Add more white
Line 10--Off White
Dk--Rem. Greenish Umber + tch RU
Md--Dark + TW, 1 pt to 3 pts
Lt--Md. + TW

Line 11--Greenish Blue
DK--PB + BS = pts
Md--Dark plus TW, 1 pt to 3 pts
Lt--Md. + TW
Line 12--Blueish/Grey
Dk--Prussian Blue + BU = pts
Md--Dk plus White 1 to 3
Lt--Md. + TW
Line 13 Gray/Blue
Dk--Rembrandt Indigo Blue
Md--Dark plus more White
Lt--Md. + TW

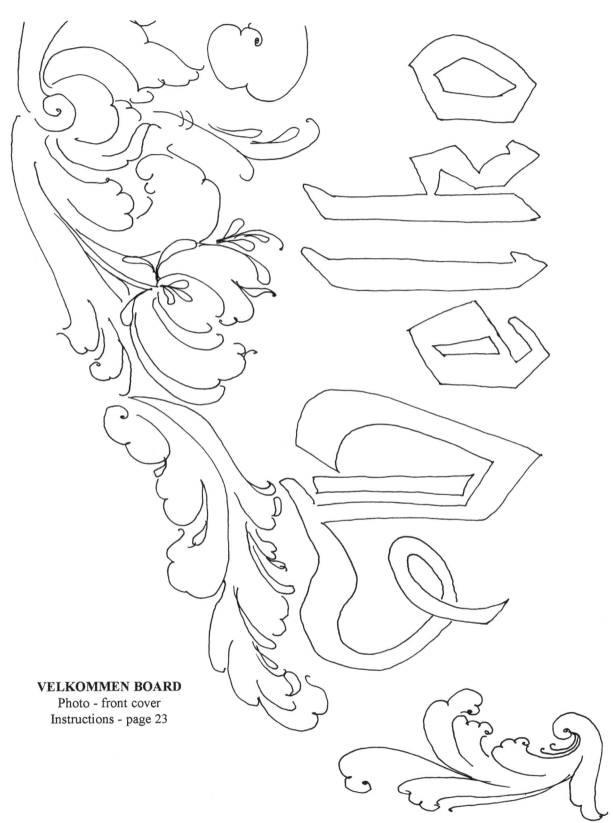

VELKOMMEN BOARD
Photo - front cover
Instructions - page 23

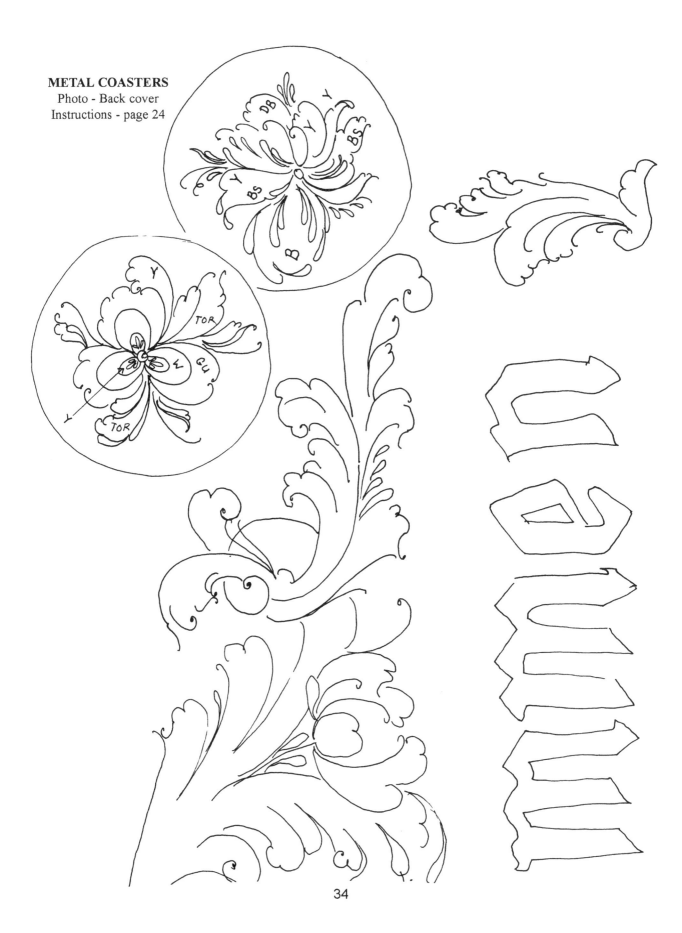

METAL COASTERS
Photo - Back cover
Instructions - page 24

34

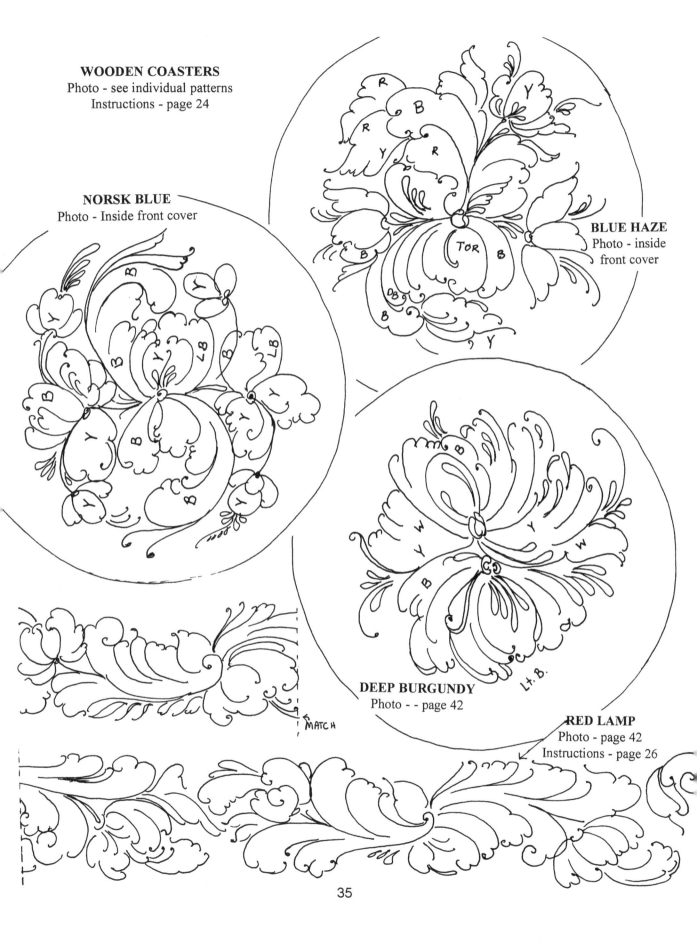

WOODEN COASTERS
Photo - see individual patterns
Instructions - page 24

NORSK BLUE
Photo - Inside front cover

BLUE HAZE
Photo - inside
front cover

DEEP BURGUNDY
Photo - - page 42

RED LAMP
Photo - page 42
Instructions - page 26

35

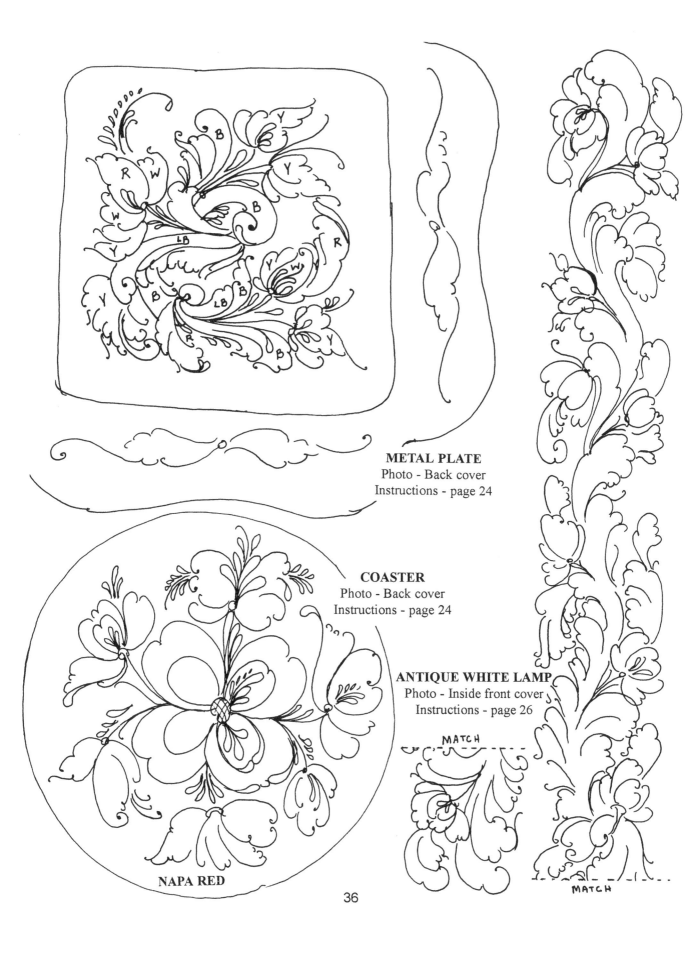

METAL PLATE
Photo - Back cover
Instructions - page 24

COASTER
Photo - Back cover
Instructions - page 24

ANTIQUE WHITE LAMP
Photo - Inside front cover
Instructions - page 26

MATCH

NAPA RED

MATCH

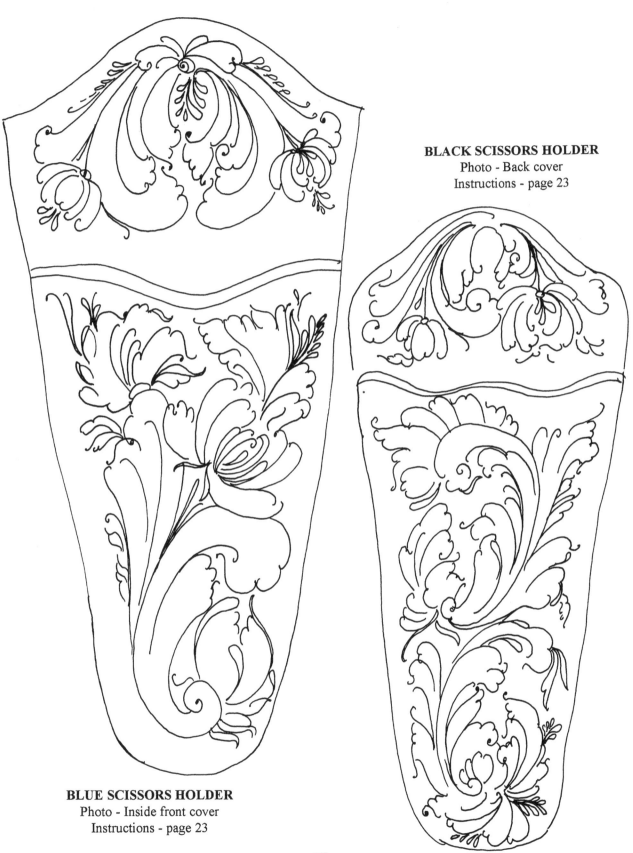

BLACK SCISSORS HOLDER
Photo - Back cover
Instructions - page 23

BLUE SCISSORS HOLDER
Photo - Inside front cover
Instructions - page 23

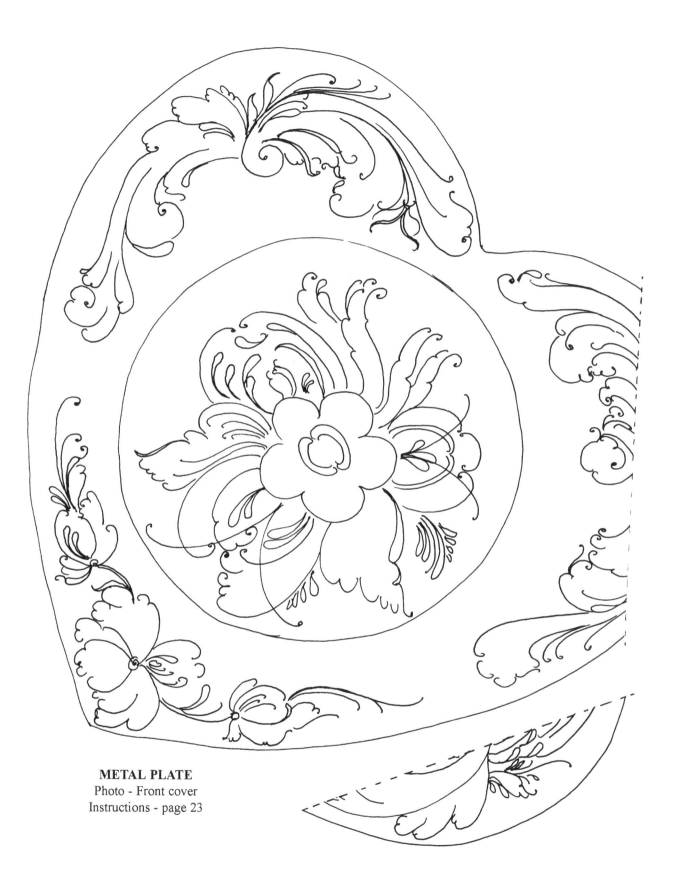

METAL PLATE
Photo - Front cover
Instructions - page 23

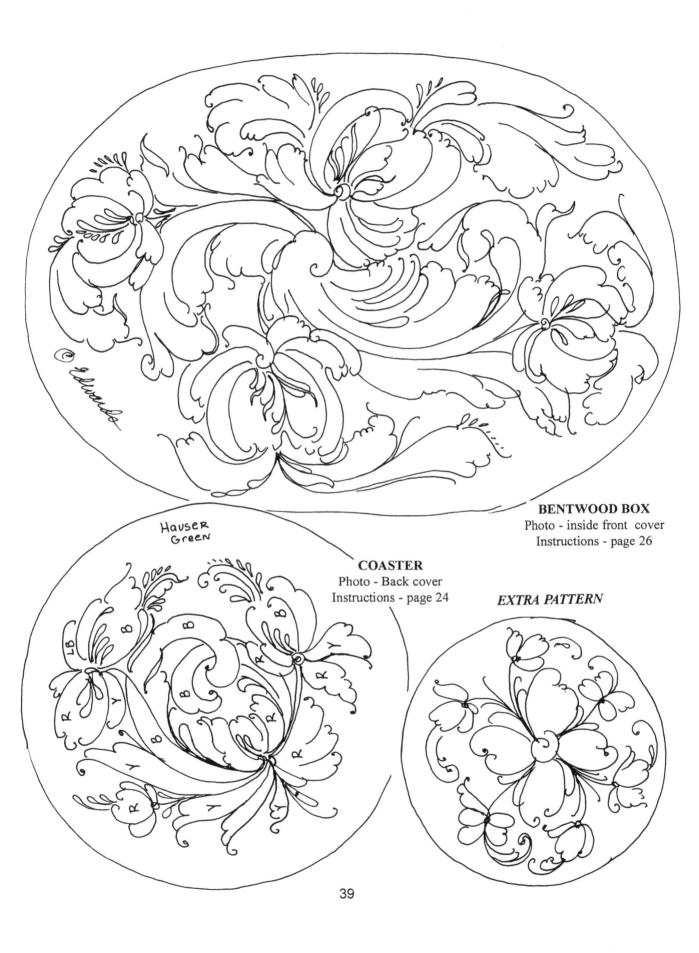

BENTWOOD BOX
Photo - inside front cover
Instructions - page 26

Hauser Green

COASTER
Photo - Back cover
Instructions - page 24

EXTRA PATTERN

39

BENTWOOD BOX
Photo - inside front cover
Instructions - page 26

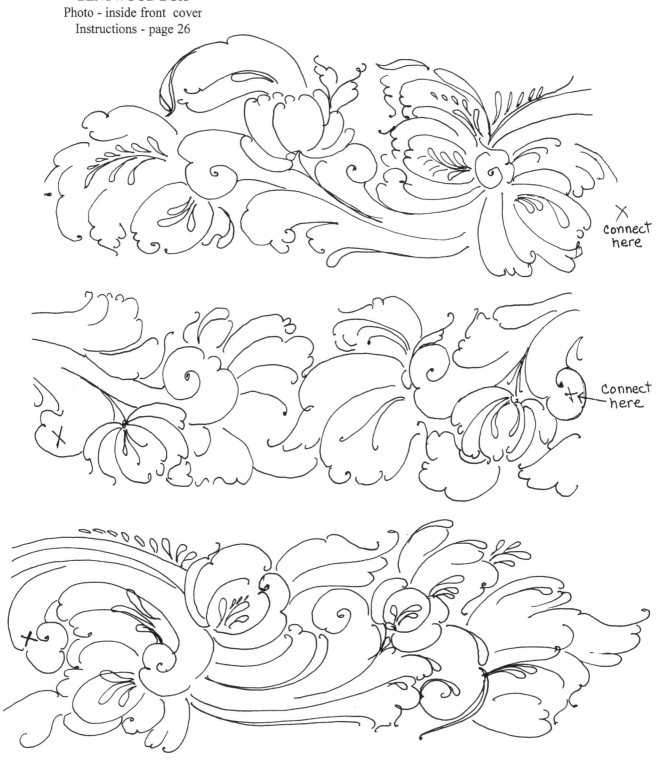

X
connect
here

connect
here

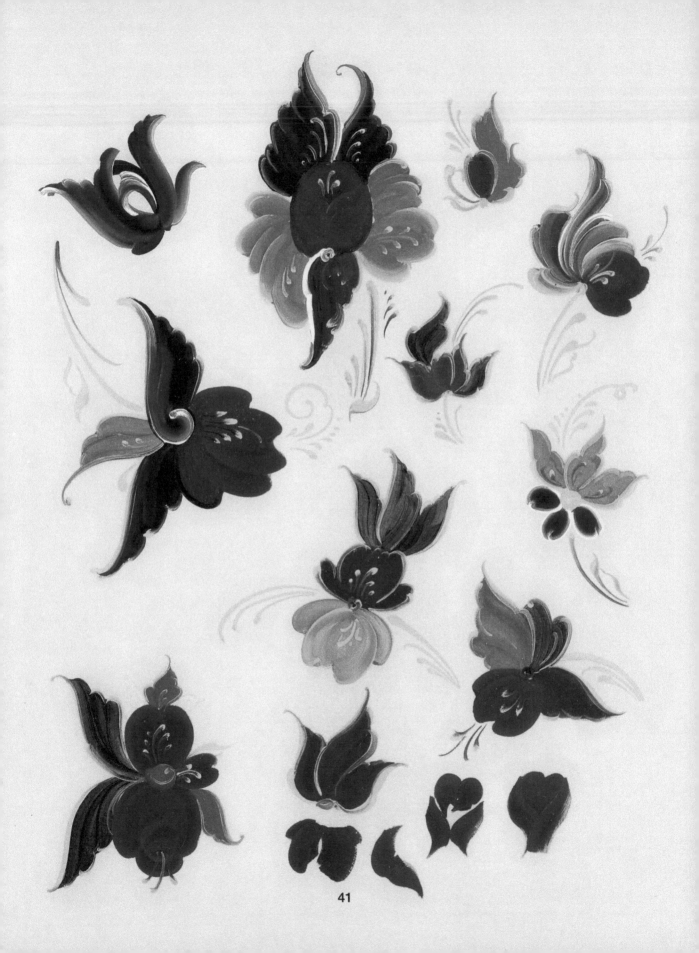

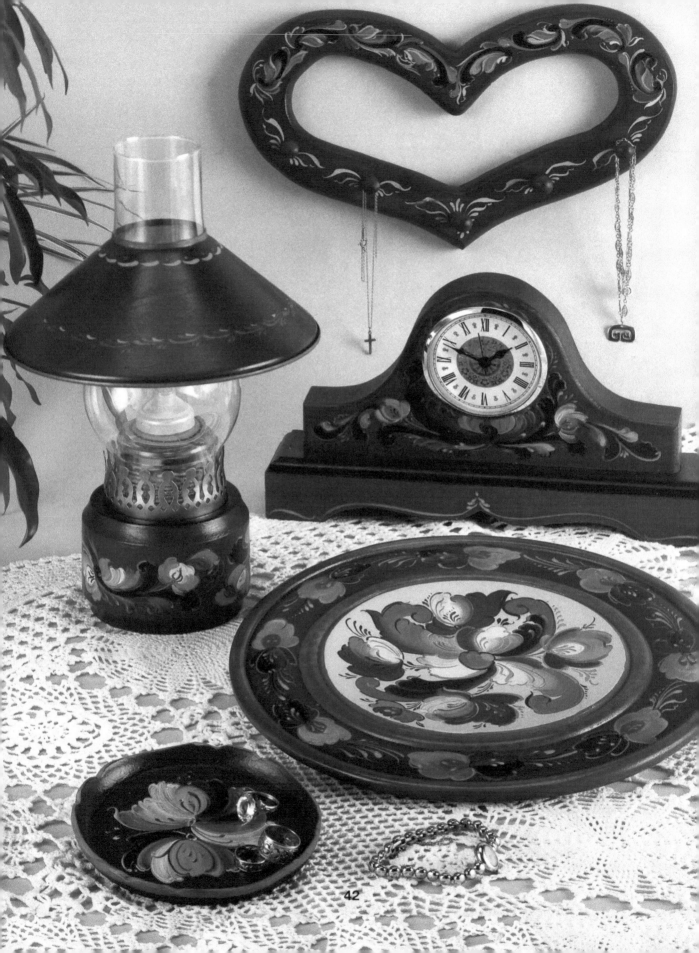

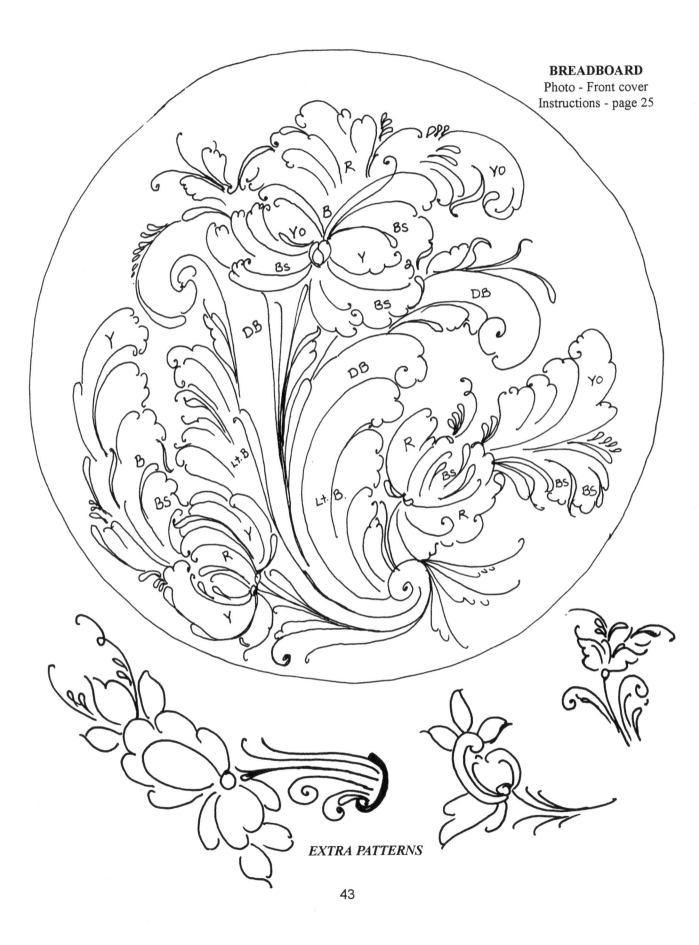

BREADBOARD
Photo - Front cover
Instructions - page 25

EXTRA PATTERNS

43

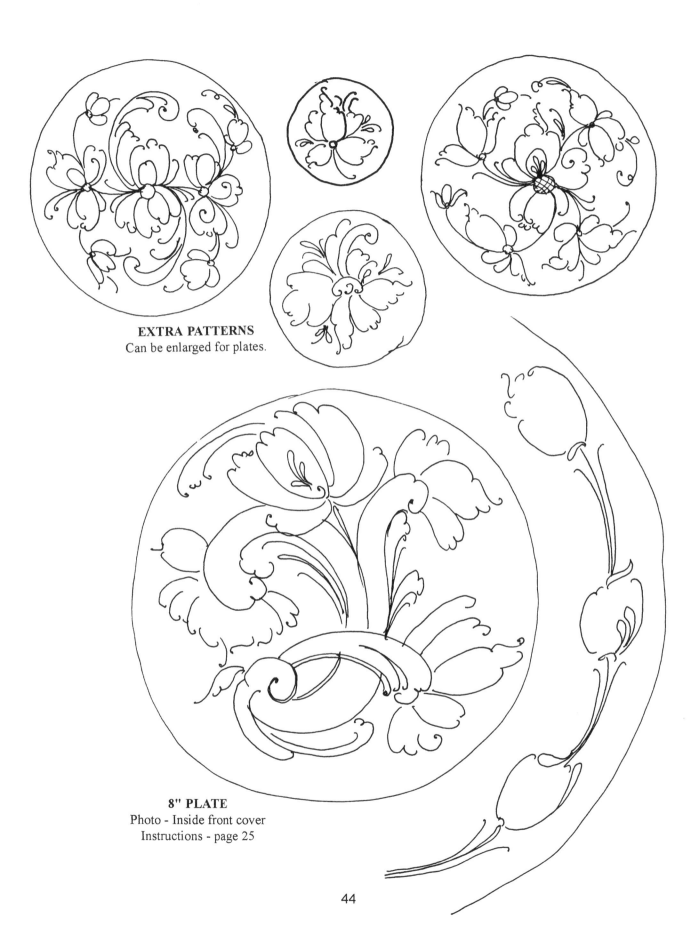

EXTRA PATTERNS
Can be enlarged for plates.

8" PLATE
Photo - Inside front cover
Instructions - page 25

Sources

www.nordic-arts.com
www.DianeEdwardsArt.com
www.Ingebretsens.com
www.blondell.com
 Antiques
www.vesterheim.org
Norwegian American Museum
www.americanswedishinst.org
Swedish Institute in Minneapolis
www.scandiamn.com
Gammelgarden Museum in Minnesota
www.skandisk.com

Sources for wood:

Lusk Scandia Woodworks, cupboards,
Trunks, unusual Nordic pieces
www.luskscandiawoodworks.com
Turn of the Century Wood Products
Beautiful plates and bowls
www.turnofthecentury-in-com
Turns In Time, Ltd.
Plates, bowls, stools, etc.
www.turnsintime.com
Norwegian Woods, Cupboards, bowls
www.atouchofnordic.com
Viking Woodcrafts Supplies
www.vikingwoodcrafts.com
Norsk Woodworks, carving
www.norskwoodworks.com
Hofcraft, Wood and Paint Supplies
www.Hofcraft.com
Rosemal Wood,Beautiful Tines
www.rosemalwood.com
Norskedalen Heritage Wood
www.JoanneMacvey.com/home/wooden
ware.htm

BOOKS BY DIANE EDWARDS
 Design Basics for Telemark
Rosemaling, Vol 1 and 2
3. Rosemaling Boxes
Norwegian Rosemaling for Young
People

4. Aarseth's Rosemaling Design
by Diane Edwards and Sigmund Aarseth
5. Painted Rooms by Gudmund Aarseth
6. Swedish Folk Art,
Floral and Kurbits Designs
(2005, 88 Pages, patterns)
Published by:
Nordic Arts www.nordic-arts.com
3208 Snowbrush Place
Fort Collins, CO 80521
970-229-9846 Diaedwards@cs.com
Orders welcomed.

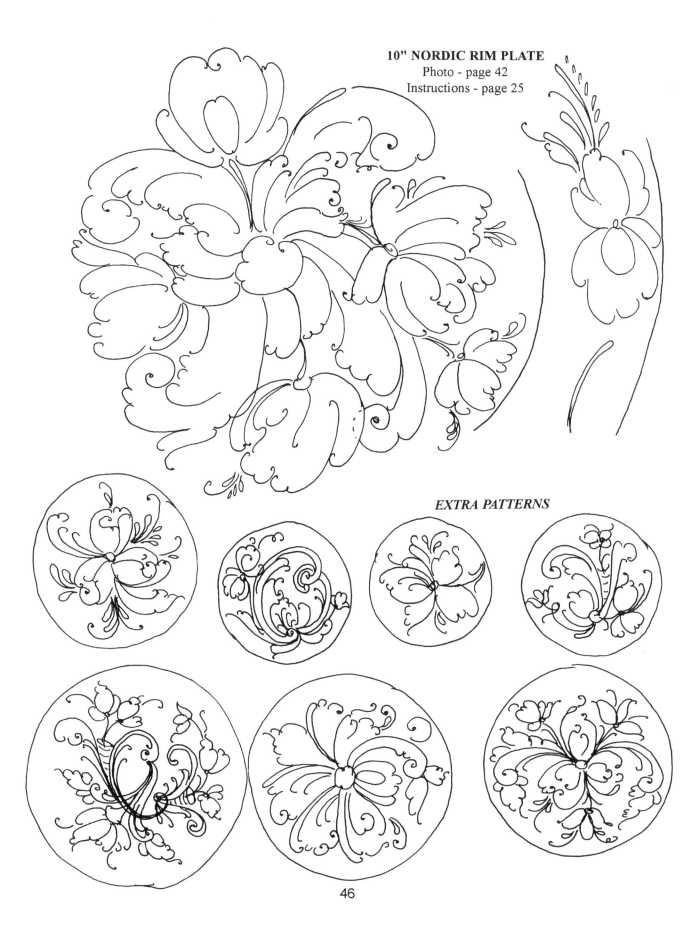

10" NORDIC RIM PLATE
Photo - page 42
Instructions - page 25

EXTRA PATTERNS

46

CHARACTERISTICS OF TELEMARK DESIGN

The general rules of Telemark design are fairly simple, but should be carefully studied to retain their authenticity.

Scrolls are of primary importance and should be seen first and not be obscured by flowers. Scrolls are oval, long, narrow and thin. The C shape is painted first, following by the S. An S scroll can be formed by two C's (forming an S) one above the other. An S alone is weak, and is best supported by a C or pulled from a flower shape.

Flowers can be small or large, but should fit the space they are painted into. They can touch or even overlap scrolls but should not obscure them. Flowers can grow out of stems that come off the roots or from splits in scrolls. Scrolls can grow out of flowers. They are abstract and made from C and S strokes. They are formed from a dot, a circle or a half-circle (crescent). They are rarely realistic.

Leaves are not of much importance—they are rarely green and aren't necessarily natural—they are often a petal.

The design area is usually one-half to three-quarters covered by the scroll shapes. IF the design area is less than half covered by the design the sense of balance is lost. Although many of the Old Masters painted right to the very edge and even over it with their designs we usually try to leave about one-half inch to one inch of space around our designs for proper balance.

Negative space is very important in rosemaling because of all the movement and circular shapes and general busyness of the positive design area. Usually about 25% of the design area should be negative space to allow for appreciation of the design itself. Because the shape of the piece is so important in the proper planning of your design use of positive and negative space, you need to carefully think through the way you will background paint your piece. It must be done before or during the planning of the design as a total comprehensive plan.

Norwegian Background Painting is usually done in one warm color—reds, oranges, golds or warm whites and one cool color—blues or greens. There are distinctive and traditional Norwegian background colors. To stay traditional these choices are slightly limited—however, they are beautiful and part of the whole Norwegian "look". Luckily, today's decorators have embraced the traditional painted look and they often design rather monochromatic rooms around these pieces so as to feature the beauty of the art form.

The hallmark of Norwegian rosemaling is backgrounding contrasts which can be done with two or three colors—usually using one or more of the colors from the rosemaling itself. Telemark rosemaling is often lazured or glazed before painting. Usually a rosemaler uses a color similar to, or a value darker than the background color to which it is being applied. Almost all Telemark rosemaling has a border, band or contrasting element to contain the energy of the design. This is achieved by several means: use of color, creating a border, painting a part of the wood piece in different colors (such as a handle or projection) and the use of antiquing or lazuring. Lazuring was often done when the first veil of oil was rubbed on. The painting was done right into the lazuring wet-on-wet. You must be very sure of yourself to do this technique! Luckily, since the paint is so wet it can easily be wiped off and redone, of course the lazuring comes with it—so it must be reapplied.

Colors were usually restricted to three, plus a light and/or dark outlining color. The choices were restricted in early times by the scarcity of colors and so were usually blue, green, red and yellow with white, dark brown or black outlining. White and the earth colors of burnt sienna, burnt umber and raw sienna and yellow ochre were also used a great deal as they were cheap and easily accessible. With the advent of Cadmiums, Cobalt and Chrome Yellows and Greens rosemaling really began to flower as painting became easier and traveling with tube colors allowed for easier transport. However, as more and more paint colors became easily available rosemaling began its decline as the sure sense of handling colors and their relationships to each other became lost in a rainbow of color.

BACKGROUND PREPARATION is extremely important in Transparent Telemark due to the thinness of the rosemaling paint. The piece should be smooth and feel hand- friendly—no rough spots or slivers. Bottoms and backs of pieces were usually unfinished or simply sealed. Insides of boxes and containers were either painted white or finished with mineral oil if food containers.

THE HISTORY OF ROSEMALING

To understand the different styles you must study the Norwegian psyche and the traditions of the different valleys. The Telemark area is more open and accessible than some of the other valleys that developed strong rosemaling styles. Nils Ellingsgaard's book, "Norwegian Rose Painting" and the Aarseth-Miller book "Norwegian Rosemaling" give descriptions of the characteristics of the people in the different valleys.

The introduction of classical styles into the European and Scandinavian areas about 1700 began the interest in decorative painting in Norway. The first stylistic element was the acanthus leaf. This rather inauspicious Mediterranean plant has two forms, a soft vine and a stiff thistle. Both of these are incorporated into rosemaling design but particularly the vine. Designers were inspired by the acanthus leaf several centuries before Christ, but it was the incorporation of this vine into the Renaissance decoration with its proliferation of foliage and floral art that made the acanthus leaf develop into an important element in painting and wood carving. In Norway, it was wood carving that first used the acanthus leaf and vine, the Renaissance tendril. This was the forerunner of the rosemaling scroll, and in Norway incorporated the ribbon animal of the early Vikings. Renaissance vines were done in a symmetrical style which was very appealing to wood carvers of doorways and architectural elements.

The Guild painters of the time used ideas from the printer's plates that came from the Continent. The Guild painters executed these carefully with much blending and shading of colors. These trained painters are not considered rosemalers, but rosemalers saw this painting and gained inspiration from it.

ROSEMALING SCROLLS developed from the Renaissance tendril which was a long C and S form. The Renaissance vine was painted as a mirror image, as was the Baroque scroll/vine that followed. This symmetrical design inspired the Hallingdal and Rogaland artists, but it was the Rococo design influence that really appealed to the Telemark artists. Rococo designs are made up of scrolls, also, but they are oval in shape rather than round and are rather freeform. The rococo style was painted in almost all the districts in Norway, sometimes as a frame for a scene, or just crosshatched in the middle. The colors of rococo were pastel and transparent and so the colors of Telemark, while not pastel, do approximate the rococo colors more than other styles of rosemaling. Other classical styles which affected rosemaling were the Regency style which is seen often in the work of Thomas Luraas who used its band connection between scrolls; and the Neoclassic style which creates strong formal frames and is a rather symmetrical style better used with Hallingdal.

The Rococo style was based on a shell motif, the word rococo comes from the French ROCAILLE which means shell. If you look carefully at the rococo designs you can see the sea motif. There are shells (scrolls) which are painted in almost any position—they are not attached to a central root as are the earlier scrolls. They can loosely frame a cartouche or open design area. Telemark artists were inventive and independent and this freeing up of the scrolls appealed to their interpretation of the rosepainting designs. Telemark rosemaling developed as a lyrical and expressive freehand stroke—usually painted over a thin rubbing of oil. The dominant features of this style can be seen most clearly during the years 1800 to 1859. The earlier styles were more symmetrical and the later painting became stiffer and less transparent.

The Telemark artists took from rococo design what they most liked and disregarded the rest. They retained its freedom and spontaneity, its freshness and transparency. They strengthened the design quality by giving it a central root, stronger earth tones instead of weak pastels and created a visually pleasing rhythmic design that could move anywhere and fit almost anything.

Some of the most important Telemark artists were: Knut Mevastaul, who decorated a room in a farmhouse near Seljord which we were lucky enough to study and photograph. His use of lazuring was exceptional. Nikuls Buine, from Fyresdal. Hans Glittenberg, Tor Oykjelid and Bjorn Bjaalid. Thomas Luraas from Tinn, was legendary and the whole Luraas family was involved in rosemaling. Three very good painters after 1860 were Halvor A. Teigen, Olav Geiskelid and Halvor O. Jonsjord. For examples of work by these and many other exceptional Telemark rosemalers, the three Telemark books by O. Vesaas are wonderful resources. These are available from Vesterheim.

A CRITIQUE FOR DESIGNS

*Paint — opaque and transparent?

*Lines — thick and thin?

*Strokes — some straight, some curved?

*Texture — smooth, choppy?

*Intensity — bright and dull—one color queen?

*Color — warm and cool—one predominates?

*Strokes — some short, some long?

*Variety — is the center part more interesting than the edges?

*Flowers — are they from the same family, or is there one orphan?

*Value — is there both light and dark?

*Hue — do the colors go together, do they feel related?

*Balance — are the biggest strokes in the center area, are the colors well-distributed around the design?

*Background — does the design seem to fit the piece — are the colors well-integrated into the rosemaling? No surprises?

*Space — is the negative space of the background design area less than the positive space? Is there enough negative space so the design doesn't crowd its area?

*Details — do they seem to relate to the design and follow through on its flow? Is there dark and light overlay? Accents? Are these colors in good balance? Are any of these details intriguing, interesting, eye-catching? Or are they boring and just following the stroke design that's there?

*Personality — do you see something of the artist's personality and personal touch in this painting? Does it look like it was a job of love and joy or just a job?

*Edges — are some of the strokes strongly edged—double loaded or just strongly outlined, are some of the strokes softly edged or "lost" edges?

*Professional finish — does the piece look well-finished? Is it exciting to look at, does the whole piece look like a marriage of rosemaling to wood—or is it verging on legal separation?

*Design elements — do most of these occur in this piece, good lines, nice color, good balance, correct values, correct use of space, variation of strokes, color and shapes?

*CHECK FOR COLOR BALANCE — Cover half your painting with a sheet of paper—are all the blues on one side—reds-golds? Is it out of balance size-wise, overlay all on one area? Move the paper around to evaluate your design.

*** USE COOL COLORS ON WARM BACK-GROUNDS AND WARM COLORS ON COOL BACKGROUNDS.

WARMS-reds, golds, off-whites, browns, stains.
COOLS-greens, grays, blacks, blues, greyish browns.

Intertwining scrolls are a lot of fun to do, especially with Transparent Telemark. Because of the transparency of the paint you can interweave the scrolls to get some interesting effects. Different media produce different effects. Oils stay wet so that you will move the color if you go across another scroll. (Acrylic will not give this effect unless you paint into a coat of retarder-be sure the retarder is on very thin and there are no puddles.) There are times when I stop before a scroll-lift the brush and then continue the stroke. This effect is actually more difficult than the one where you paint across the scroll because you need to be correct when resuming the stroke.

It is very important that you bring these scrolls from the proper roots, in the correct shape. If you study old painting you will see there are dozens of ways to do this. The general rule is not to obscure your first scrolls. They are more important than subsequent ones and need to show. As you work out into the design remember that your colors should be less bright and outlining should be more soft and muted. When you study old rosemaling, you will see that the main scrolls are always the most important. Experimentation and discovery are the idea here. You only have to wander through a museum full of old trunks to see the cleverness and creativity of the old rosemalers. They didn't really seem to care too much about proper anything, it was just a love of painting and color to them. But when they were good they were very, very good!! In Telemark I photographed some trunks that were so beautiful they would just make your teeth ache. The linework was so fine and expressive, it seemed to touch down and then soar over those interwoven scrolls. What a joy to see! It certainly inspired me to come home and work on scroll designing. I have come to love it, and I think you will, too.

BASECOATING INSTRUCTIONS

For oil backgrounds—sand your piece lightly and wipe off with a tack cloth. Fill any holes or defects with JW ETC Putty. Sand this lightly and wipe. It is best to put on a thin first coat of paint. Let this first coat dry over night and then sand, wipe and recoat. Some of the deep oil base colors take more than two coats so you will have to decide if the paint is smooth and covered well enough. Be sure to keep oil coated pieces somewhere that is as dust-free as possible as they do attract dust as they dry.

For acrylic backgrounds — sand your piece and wipe. Fill holes. Sand and wipe putty areas. Base coat the piece using a little water with your paint. Again, the first coat should be fairly thin—since acrylic gets rock hard when dry, it is best to sand your piece when it is still cool to the touch. You also get less sanding dust to inhale and it's a lot easier to sand. After this coat is dry and wiped, apply a second coat. With this coat you don't want any water, however, you don't want a thick coat here either. Heavy coats are difficult to work with, and also Norwegian Rosemaling is historically done on thinly painted backgrounds—the wood grain can show slightly so that your piece doesn't look like plastic. Usually in Norway, trunks, for instance, were painted with one coat of a pigment and linseed oil mix. Surprisingly, the thinner paint jobs tend to last longer as they are less likely to peel, blister and flake off.

When your oil base paint is dry you may begin your rosemaling. If you find flaws you must touch these up and let this whole area dry over night before proceeding. IF your oil paint was applied too thickly you might have to lightly sand your piece and produce a little tooth for the paint to adhere to. A smooth surface is nice, but it can also become too smooth, and this is quite frustrating. Some people sand SO well that you can see the harder ribs of the pine showing—this is why I don't usually care for sanding machines, the piece loses its character.

When your acrylic base paint is dry you will need to use a piece of brown paper bag and really rub your background as though you were sanding it. This seals the acrylic slightly and provides a nice smooth surface to paint on. IF you have flaws in your coat and you later plan to antique—DO NOT fix these little areas with patches of paint—this will show. You must repaint the whole thing or else don't plan to antique this piece.

IN CONCLUSION:

The peasant culture of Norway or "bondekultur" existed due to the pride and joy of Norwegians in their homes and their churches. It was a mark of culture to be skilled in a craft and rosemaling was one of the most respected of the folk arts. Rosemaling had a definite function and everything that was decorated was also used in most homes. It was a mark of a prominent person who had a whole room decorated with rosemaling. Although rosemaling can be quaint and even crude in some areas, the Telemark artists brought rosemaling to its peak with their swift, free and glorious strokes—outlined with the finest and most spectacular lines that were free and unrestricted. Strength of stroke, graceful of line and enchanting color were the hallmarks of the Telemark rosemaler.

Hopefully, this book will help explain some of the mysteries of the design process and give you the incentive to start the journey.

BIBLIOGRAPHY:

*Ellingsgaard, Nils: Norwegian Rose Painting. Det Norske
Samlaget. Oslo. 1988.
*Ellingsgaard, Nils: Norsk Rosemaling. Det Norske Samlaget. Oslo. l981.
Handell, A: Intuitive Composition. Watson- Guptill., New York, New York. 1989.
*Henry, Hildy: Faux Finishes. 1986. 2145 Slater St., Santa Rosa, California. 95404
*Miller and Aarseth: Norwegian Rosemaling. Charles Scribner's Sons. New York, New York. 1975.
*Innes, Jocasta: Scandinavian Painted Decor. Rizzoli. New York, New York. 1990.
*Vesaas, Oystein: Rosemaling i Telemark. (In Norwegian.) Three volumes. Norske Minnesmerker. l986. (l953-l957).
*De Dampierre, F.: The Best of Painted Furniture. Rizzoli. New York, New York. 1987.
*Stewart, J: The Folk Arts of Norway. Dover. New York, New York. 1972.

Norwegian-American Museum, Vesterheim. 502 W.Water Street • Decorah, Iowa 52101
Members get a discount of 10%. Rosemaler's Supply Catalog and Rosemaling Letter. Ask about joining!

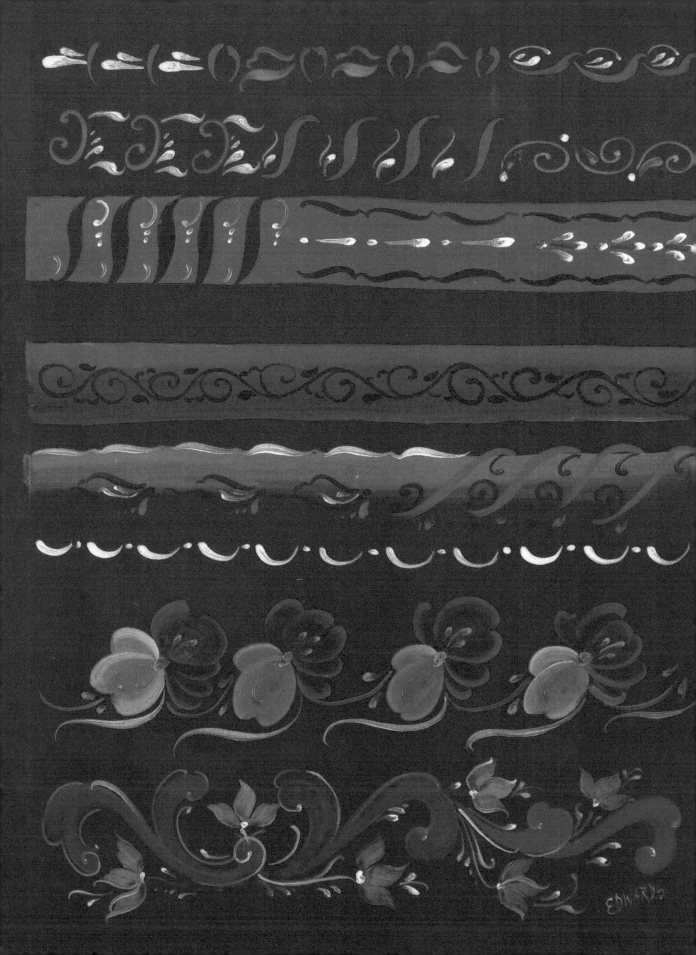

CPSIA information can be obtained
at www.ICGtesting.com
Printed in the USA
LVHW072116081022
730285LV00002B/5

9 781463 734756